LET MY
PEOPLE
GO

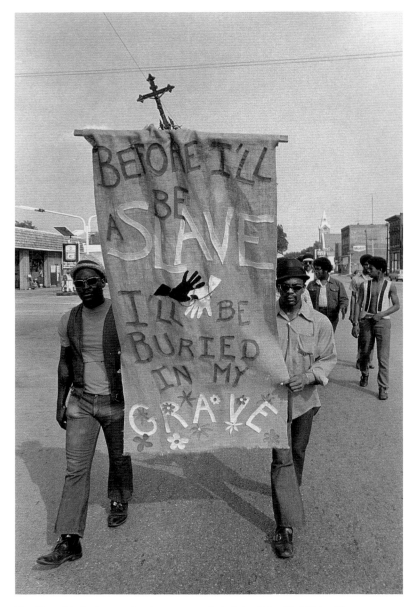

Marching with the banner that became a symbol of the Cairo Civil Rights Movement. Downtown Cairo. July 1969. *Left,* Wade Walters; *right,* Clarence Dossie.

"I was mostly up in front or just participating. I was never no ringleader or nothing, you understand. I just believed in what I was doing. And my belief—I believe I would die for what I believed in." —Clarence Dossie

LET MY PEOPLE GO

CAIRO, ILLINOIS
1967 - 1973

CIVIL RIGHTS PHOTOGRAPHS BY
Preston Ewing Jr.

EDITED BY
Jan Peterson Roddy

SOUTHERN ILLINOIS UNIVERSITY PRESS ■ *Carbondale and Edwardsville*

Library of Congress Cataloging-in-Publication Data

Ewing, Preston, 1946–
 Let my people go : Cairo, Illinois, 1967–1973 : civil rights
photographs / by Preston Ewing, Jr.; edited by Jan Peterson Roddy.
 p. cm.
 Includes bibliographical references.
 1. Civil rights movements—Illinois—Cairo—Pictorial works.
2. Civil rights demonstrations—Illinois—Cairo—Pictorial works.
3. Cairo (Ill.)—Race relations—Pictorial works. I. Roddy, Jan
Peterson, 1957– . II. Title
F549.C2E85 1996
305.8'009773'999—dc20
ISBN 0-8093-2085-1 (alk. paper) 96-7578
ISBN 0-8093-2086-X (pbk.:alk. paper) CIP

To my daughters,
Carmel, Maya, and Melodi,
who were probably too young to
understand why civil rights activities
prevented me from being with them as
much as I wanted to be. And to the black
people of Cairo whose continuous support
of the Civil Rights Movement was
responsible for the reduction of racial
discrimination in Cairo, Illinois.

—Preston Ewing Jr.

To my partner, Julie Sutfin,
for her abiding love and support.
And to my mother, Ruth Roddy,
and my aunt, Florene Peterson,
who by example taught me the value of
fighting when necessary and possessing
compassion when possible.

—Jan Peterson Roddy

CONTENTS

EDITOR'S PREFACE

CAIRO, ILLINOIS, is located at the southern tip of the state, one hundred sixty miles north of Memphis, Tennessee, and three hundred sixty-five miles south of Chicago. The Ohio River flows into the Mississippi River at Cairo, and the town borders the states of Kentucky and Missouri. With its low elevation and location between the two rivers, the site of what is now Cairo was subject to frequent flooding, and all attempts to establish a community in the years between 1700 and 1800 were unsuccessful. In 1820, approximately twenty black slaves were brought to the site and erected the first buildings. For black residents, it was the beginning of a long history of injustice in the community that continues to this date.

In 1843, flood levees were completed, and by 1860, the population had grown to 2,188. During the Civil War period, 1860–64, Union forces operated out of the Cairo area because of its ideal location near the Southern states. After the war, Cairo continued to grow along with the riverboat traffic. The census of 1900 reported a population of 12,566. As their number in the community grew, black citizens increasingly found themselves victims of racism and violence. Whites enforced complete racial segregation even though it was prohibited in schools and public places by Illinois state law. Black men were lynched. In 1918, black residents organized a chapter of the National Association for the Advancement of Colored People (NAACP) to provide leadership in their fight against racial discrimination. Cairo reached its peak population around 1920, when the census recorded 15,203 inhabitants. The growing black segment of the population was fed by a steady migration from the South. During this period, a proposal was made to expand the city's boundaries by incorporating land for the future development of industries that would be needed after the demise of a river-based economy—a proposal that was tabled when it became apparent that such an expansion would also entail a significant increase in the number of black voters. Since that time, the population has continuously declined, due to a complex series of economic trends and societal changes. In 1990, the figure had dropped to 4,700.

During the 1940s and 1950s under the banner of the NAACP, black residents continued their struggle for the elimination of injustices against them and were successful in obtaining equal pay for black teachers and public school integration. In the early 1960s, they made gains in ending segregation in public places such as movie theaters and restaurants. Then the hanging of

a black soldier in the Cairo police station on the night of July 15, 1967, moved the black community to such anger that it organized the biggest political protest movement Cairo has ever seen. Through civil rights marches, lawsuits, picketing, and an economic boycott, black citizens were successful in making significant changes in their lives and in the community. This intense and determined effort continued until 1973.

This book, then, is an account of significant events witnessed by members of a community that was being mobilized into a movement. Except for its late inception, the struggle in Cairo was much the same as that in other towns and cities throughout the United States in what we now call the civil rights era. In two important ways, you are allowed to see inside a part of the most powerful grass-roots movement our country has ever known: by studying the faces and by listening to the voices of the ordinary individuals who are the soul of the movement, rather than the leaders who often come to symbolize a time and a spirit. These photographic images, made by an insider, depict the multifacetedness of the movement and the long persistence required of its members. And I have chosen deliberately not to focus primarily on sensational pictures of direct confrontation that signify only one aspect of the battles fought, lost, and won.

Presented alongside Preston Ewing Jr.'s remarkable photographs are excerpts of interviews with six persons who were actively involved in the protest movement. In addition to this photonarrative and the chronology of significant events that precedes it, two essays help to take this project several steps beyond the typical historical chronicle. Marva Nelson's foreword reflects on our current relationship to these events, how the "now" is shaped by the "then." In her concluding essay, Cherise Smith offers thoughts on this accounting process itself, tracing the roots, and considering the consequences, of the visual image as documentation and interpretation of civil rights history.

In the last few years, a number of interpretations of this time period and movement have attempted to define and place these events in our nation's larger history. I am not sure we have yet taken up the more difficult task of defining what that era means with regard to current race relations in our country. We embrace an incomplete vision of the continuing movement for civil rights through representations of progress that were set several decades ago. These signs seem to imply that we have arrived, that this struggle is over. Members of the Cairo black community vary in their attitudes about how far the town and nation have come in renouncing the shameful legacy of racism, from tempered optimism to a pessimism that is born of continuing disappointments. Most would agree that the unbridled and overt evidence of a segregationist mentality has changed and that legal victories have begun to transform the face of influence in public institutions. Some will disagree over how deeply attitudes have changed and tangible power has shifted. I risk leaving you with this complex reality rather than a far too simple, happy ending.

The six individuals whose remembrances are included as narrative text are representatives of a diverse black community. My hope is that the truths that echo in these stories and pictures exemplify, as much as is possible, the commitment, sacrifices, and pride of the larger black community of Cairo who came together against all odds. The contributors to this book are all of African American or mixed-race descent, with the exception of some of the initial researchers and myself. A great effort has been made to keep the community, to whom this history belongs, in as much control over significant portions of this project as possible. Edits of photographs and text were finalized in consultation with their source, and essentially all other significant decisions were made in collaboration with Ewing.

The ninety or so photographic images included here were culled from thousands of negatives taken by Ewing of events during this period. In each case, I considered both the informational value and formal qualities of the photo. I was frequently reminded of the difficulty of achieving this balance when he questioned my attachment to one image over another. On the whole, I am confident that neither priority has been compromised, although in any individual instance, one may have given way to the other. The particular aesthetic ordering within the images fills them with their emotional insistence, from irony, to passion, to cool consideration, while it is the information they impart that truly bears witness to remarkable deeds and times, even in this age of skepticism about the truth-telling capability of any representation.

Excerpts were gleaned from longer narratives to help give context to the photographs, filling in background and details lost in the evocative but sometimes ambiguous message that is inherent in the photographic image. The placement of narrative quotes near particular photographs seldom implies a literal correspondence between text and image but rather allows the image to serve as a symbol for similar events. The narrative excerpts were edited for clarity, with every effort being made to preserve the original colloquial structures and rhythms that help to weave individual voices into the collective identity. Within any group of people who have experienced oppression by a dominant class, some aspects of expression and experience are reserved for trusted insiders. I suspect that among the individuals who graciously share their memories here, some of them may have been ambivalent about speaking to researchers—some of whom were white—but they also seem enthusiastic about having their stories told.

The interviews from which the narrative excerpts were taken were conducted by students in a graduate sociology fieldwork seminar. These oral histories were compiled from a series of three interviews taken over a three-month period. The scope of the questions ranged from the pre-boycott era (before 1969) through the present, with more focus on the movement years of the late 1960s through the early 1970s. The oral history narrators are identified by their initials in the photonarrative section of the book, and brief biographical sketches of them appear in the list of contributors.

The terms *black* as well as *African American* appear in this volume. As Henry Hampton states in his preface to *Voices of Freedom* (New York: Bantam, 1990), "We are in a time of linguistic transition" with regard to the language of identity. *Black* (conventionally lowercased as is *white*) continues to be the preferred expression of racial identity within the Cairo community, so it is used most often in the narratives. The authors of other portions of this book understandably had strong feelings about their own use of one term over another, which I have respected. In editing the narratives, I felt it was important to preserve as much as possible the rhythms of oral speech, so I have not attempted to homogenize usage or style but have followed standard editorial practices. Ellipses are used to mark only extensive omissions of text. Brackets are used to enclose editor's clarifications.

Preston Ewing Jr. and I began working on the photo exhibition from which this book has grown over six years ago. I cannot begin to say how much I have appreciated and learned from this experience. I am truly grateful for his trust and partnership.

ACKNOWLEDGMENTS

Endeavors such as this one are in every sense a collaboration. Jan Peterson Roddy and I want to thank the following groups and individuals for their assistance: the Illinois Arts Council; the Illinois Humanities Council; the Office of Research, Development, and Administration and the Department of Cinema and Photography, Southern Illinois University at Carbondale; Tamala Anderson and Kevin Miller, for their support of the early exhibition from which this book has grown; Dr. Kathryn Ward and Dr. Mareena Wright, for their direction of the initial interview process, and their students from the graduate fieldwork class in the Department of Sociology at SIUC who conducted those interviews, including Susan Daniel, Lois Eldridge, Carrie Forshner, Ann Herda, Mary O'Hara, Marva Nelson, and Myrle Wasko; and everyone at Southern Illinois University Press, for their commitment to this project.

My very special thanks also go to James Brown and Carl Hampton for their contributions to my photographic interest, development, and preservation activities. The photographs contained in this book, and many others of the Civil Rights Movement in Cairo, are a part of the photographic collection of the Ewing/Kendrick Museum of Black History, which is scheduled to open in Cairo in 1996.

MEMORY'S LESSONS

Marva Nelson

PHOTOS, newspaper clippings, old report cards, obituary notices—these holy mementos are stashed in the reliquary of my mother's chest of drawers. They bulge with decades of family history. My visits home often find me browsing through the photos. We talk about physical resemblances, resemblances in attitudes, likes and dislikes of family, and the similarity of events that have occurred over spans of time. As I listen to Mama telling stories, infusing the events and people in the photos with life, I marvel at the circularity of history.

Historical events are traditionally viewed through linear lenses. Events are recorded, stored in history books, shelved in libraries, displayed in museums—reference points for occasional reflection. However, listening to my mother making history flowing and fluid, I visualize the linkages from the past to the present and even to the future. I realize that, no matter how hard we attempt to sterilize our history, it is resilient, resisting our best efforts to sanitize and shelve select sections, storing them out of memory's view until it suits our needs.

In 1991, I viewed an exhibit of Preston Ewing Jr.'s photographs, "Let My People Go," a photonarrative of the struggle for civil rights in Cairo, Illinois. What goes around does indeed come around. Assaulted by the anger, frustration, fear, and pride contained in the photos, I found myself confronting the ties that still bind me to Cairo. During the period of Cairo's Civil Rights Movement, I was dealing with the emotional onslaughts of impending adulthood and striving to define myself as an African American woman, living not only in southern Illinois but in America. Even though my family resided in a little village a few miles north up the road, the Civil Rights Movement in Cairo played a critical role in our lives. My father attended Sumner High School. Both parents worked in Cairo for many years, my mother as a teacher, my father as one of the first African American Illinois state troopers. My sisters, brother, and I made friends with children living in and around Cairo.

During my childhood and early adolescence, my family traveled to Cairo at least once a month to shop. In the shops, I encountered many of the unwritten rules of racism. Saturday mornings found Commercial Street full of cars and activities as families, black and white, moved in and out of the stores—S. H. Kress, Woolworth's, J. J. Blum, Maxine's, Mode O' Day, Khoury Brothers, Michelson's, The Cairo News and Music Store, and Curtis and Mays Photo Studio. These are only a few of the stores I remember.

Some of the Cairo merchants greeted their black customers with quiet

courtesy. More often than not, the money was plucked from our hands, the store owners sullenly accepting our presence. In these places, we were met at the threshold with overt rudeness and hostility. Some store owners and clerks blatantly questioned our ability to pay, making snide remarks. Many attempted to stop us from touching anything. My mother would always severely caution us, "Keep your hands to yourself." "Look but don't touch!" Constrained by my mother's warnings and the contemptuous looks and manners of the store personnel, I often walked in these stores, arms locked tightly to my sides. I felt contaminated, unclean.

There were restaurants we simply knew not to go into. Only a few white-owned sit-down eateries welcomed black folk. In fact, I recall eating only at the local burger joints. Even there, we would pull up to the drive-in portion, order our food through the speakers, and eat in the car or take it home.

The boycott of Cairo's stores during the height of its civil rights struggle has frequently served as the focal point in discussions of Cairo's current state of social malaise. However, other critical moments preceding the boycott help to lay open the wounds of racial disparity. In 1967, Robert Hunt, a young African American soldier, was found hung in the Cairo jail. The furtive actions taken by the Cairo Police Department immediately following Hunt's death, coupled with evidence contradicting the explanation of his death as a "suicide," outraged the African American community. Voiceless, denied access to equal participation in the school system and city government, the community seethed with racial resentment. Hunt's death sparked several days of rioting in the city. But even before this, the event that kicked the machine of racial resentment into gear was the opening in 1963 and summary closing of the city swimming pool.

The swimming pool rested almost in the heart of Cairo. Riding in the family car, we would pass by it on our way to the shopping district. I was mesmerized by the pristine, blue water. The only access to water for swimming, prior to the building of the pool, was the creeks, streams, and rivers surrounding Cairo. Every year there were reports of children and adults drowning, usually in the Mississippi and Ohio Rivers bordering Cairo. Many were victims of their inability to swim. In my own rural neighborhood, the kids "swam" in weed-covered drainage ditches flooded by summer rains. The water, an opaque brown, contained twigs, trash, and, from time to time, snakes. Arms and legs flailed in imitation Olympic strokes.

The pool represented innumerable possibilities—the most obvious, much-needed swimming lessons. More importantly, it would have afforded blacks and whites, adults and children, some of the most important lessons of life: the true construction of friendship and citizenship.

White families chose instead to instill the self-righteous lessons of segregation in their children. Fearing the contamination of, and integration by, African Americans, the city closed the pool almost as soon as it had been opened and filled it in with concrete. As one African American citizen, Anne Winters, so eloquently put it, "You think back on these things and wonder,

'How can people be like that?'"

In my mind's eye, I can still see the closed pool: brownish-green algae floating on the water, choking the blue out, turning it a cloudy, sickly green. Kudzu-like vines crept along the walkway and walls, strangling the white concrete. Spidery dark cracks sliced through from one end to the other—a prophetic portent of Cairo's impending divisive battles.

The complex origins of Cairo's descent into progressive obscurity are legion. Perspectives differ, depending on which residents you speak with. Some assert even now, as they did then, that Cairo was a quiet, sleepy Southern city, her inhabitants coexisting in undisturbed harmony. Outside influences intruded, disrupting tranquil ground. These "outsiders" planted the insidious seeds of racial discontent and greed.

Others contend that watershed events are responsible for Cairo's current state of purgatory. The closing of the pool, Robert Hunt's questionable death in the Cairo jail, the rabid refusal of the city's merchants to open up employment opportunities—all forced the city into communal limbo.

Today, the shops on Commercial Street are no more than gutted buildings. Tattered signs whisper in the wind of a more prosperous time. There are concentrated efforts to attract industry into Cairo that would cut inroads into an extraordinarily high rate of unemployment. Some residents are fearful they may become victims of gunfire from the drug dealers and rival gangs that plague the city and surrounding region.

Plans for a new swimming pool have been discussed on several occasions by city administrators. The faces of African Americans working in government offices, banks, and throughout the city can be seen. There are now three African American members serving on the city council, and several more are police officers. And Cairo briefly boasted of an African American police chief, my father. Unfortunately, his hiring was in response to circumstances tragically paralleling the death of Robert Hunt. In 1991, an unarmed African American man, Roy Lee Jones, was shot at numerous times and eventually killed by a white Cairo police officer, once again resurrecting the specter of racism.

Today, twenty-five years later, my struggle for self-definition and respect, along with that of other African Americans, continues—not just in Cairo but throughout the nation. Even though the civil injustices that birthed the Civil Rights Movement have been visually documented and archived, bearing witness to human illiberality and treachery, we still grapple daily with the issue of civil rights. History's ghosts haunt us, following us wherever we go.

Recently, the current mayor of Cairo asserted that the "good and rational" white people of Cairo, those holding the balance of power, fear, and ignorance, sought only to protect Cairo's best interests during this time of civil disturbance. To become entrenched in fear, refusing to face the constructive power of change is not rational. It is simply suicidal.

The racial turmoil of the 1960s and 1970s was not unique to Cairo. Across the country, innumerable cities engaged in a racial tug-of-war. "Good

and rational" people weighed the ultimate mortal consequences of their segregationist attitudes and chose to share the balance of power. As a result, some attitudes and beliefs were reshaped. Some cities became reborn and have flourished and prospered. The dogged persistence and selfishness of Cairo's "good and rational" people have sentenced the city to economic and social oblivion—living testimony to the arrogance of exclusion.

Unfortunately, memory's lessons have dimmed in the relatively short time we've learned discrimination and exclusion lead straight to disaster and tragedy. Many of us have become fugitives of the past, attempting to escape the blood of our history. As a result, there are those who ask that history, as it has been, be placed out of sight, effectively putting it out of our minds. Such is the case with the Civil Rights Movement. The movement has become known as an event that happened "back then." In essence, *movement*, defined as motion towards something, or progress, has been negated and set aside.

Some ask that history, as it is now being made, be viewed as faulty. Our eyes are not to be trusted. What we see is not necessarily to be believed. The unjustifiable beating of Rodney King by the Los Angeles police and the subsiding public outcry bear witness to this and to how quickly our memory fades.

And there are those who demand that future history be stripped naked and rendered colorless. The contributions of African Americans and other people of color are to be disregarded. Such is the case with those who assert the (re)writing of our collective histories is false and politically incorrect.

Hopefully, as we finger these photographs, turn the pages, recalling the power and emotion of the moment, we will not merely consign these fragments of our past to the reliquary of our memories. Abraham Lincoln prophetically remarked, "Fellow citizens, we cannot escape history." We must acknowledge that we are destined to repeat the mistakes of the past until we learn from them. Memory's lessons of Cairo should remind us all that the Civil Rights Movement is not over.

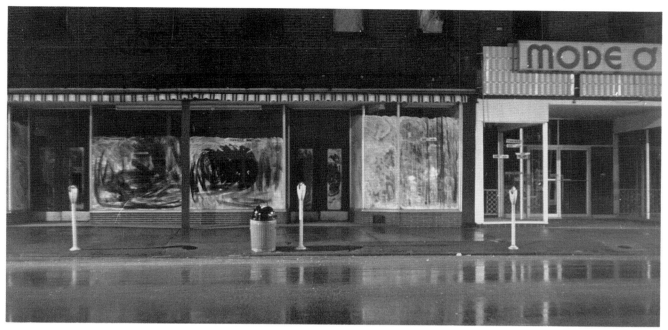

Closed business on Commercial Street in Cairo. Date unknown.

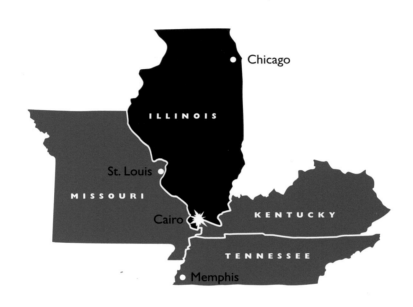

CHRONOLOGY
of the Cairo Civil Rights Struggle

1960

U.S. Census reports the Cairo population is 9,348 and 39 percent black.

1967

July 15
Robert L. Hunt, a nineteen-year-old black soldier, is found hanged in the Cairo police station. Harsh police measures taken against black protestors escalate the disorder; three days of violence follow.

July 19
The Illinois National Guard is called into Cairo.

July 24
Local NAACP president Preston Ewing Jr. writes a letter to Adlai Stevenson, the state treasurer, informing him that Cairo banking institutions will not employ blacks. Stevenson subsequently notifies these banks that they have thirty days to hire black people or the state will remove its deposits from their institutions.

July 26
An all-white vigilante group called the Committee of Ten Million, also known as the White Hats, is organized by Alexander County State's Attorney Peyton Berbling.

1968

January 30
Rev. Larry Potts, pastor of the Cairo Baptist Church, clubs to death a seventy-three-year-old black man accused by Potts of attempting to rape his wife. Potts is cleared by a coroner's jury and no trial is held.

March
The Illinois Fair Employment Practices Commission opens hearings on racial discrimination against Burkhart Factory, Cairo's largest industry. As a result, several black complainants are awarded compensation.

June
Little League baseball is discontinued to avoid integration of the ballpark.

September
Camelot, a private segregated school, is organized by Rev. Potts.

1 9 6 9

February 25 A predominantly black crowd at a high school basketball game is threatened by armed, white vigilantes with police dogs.

March 23 A Catholic priest, Father Montroy, tells a St. Louis newspaper that the White Hat vigilantes are harassing the black community, drawing national attention to Cairo.

March 24 Approximately twenty-five clergymen from southern Illinois come to Cairo to stand in support of Father Montroy. After an investigation, the clergy declare justice for the black community a "farce" and ask the state to disband the White Hats.

March 25–28 A committee of priests is sent by the bishop to investigate the situation in Cairo. They conclude Father Montroy's allegations are true and, in support of his work, send Father Bodewes to help.

March 27–29 The Illinois Council of Churches also investigates the Cairo situation and supports previous findings of other clergy.

March 31 Shots are fired at a car used by black leader Rev. Charles Koen, followed by a two-and-a-half-hour gun battle with heavy shooting into the black public housing project, Pyramid Court. During the next two years, more than one hundred fifty similar battles occur.

April 1 The United Front of Cairo, a coalition of black organizations, is formed.

April 3 The White Hats offer six hundred "volunteer deputies" to assist city and county law enforcement officials.

April 7 The United Front launches an economic boycott of white business establishments.

April 15–22 Lt. Gov. Paul Simon arrives to investigate events in Cairo. His final report calls for a new chief of police and recommends that the White Hats be disbanded.

April 28–
May 10 A special committee is appointed by the Illinois House of Representatives to investigate the "Cairo situation."

June 19 Members of the White Hats allegedly fire into Pyramid Court; a four-and-a-half-hour gun battle follows.

June 20 The Special House Investigating Committee of the Illinois General Assembly releases its preliminary report calling for the Illinois attorney general to enforce civil rights laws and for the racial integration of city and county departments.

June 28–July 1 White residents hold mass meetings in public parks. After the forced disbandment of the White Hats, many former members reorganize as a branch of the United Citizens Council of America, or White Citizens Council (later called United Citizens for Community Action).

July 7 A United Front delegation travels to the state capital to peti-

tion the governor for help but are refused admittance to his office. Governor Ogilvie calls out the state police, and over one hundred United Front members are arrested. Many remain in jail for weeks.

September 11 The Lawyer's Committee for Civil Rights under Law opens its office in Cairo.

The mayor of Cairo issues a proclamation that prohibits gatherings of two or more individuals and all marches and picketing.

September 12 A federal court rules that the proclamation and city ordinance that prohibit gatherings, marches, and picketing are unconstitutional.

October 4 Black protesters are clubbed and arrested by local and state police for marching in support of the boycott.

October 6 The federal court orders police to cease harassment and protect civil rights of marchers, narrowly averting an imminent confrontation.

October 7 The federal court issues a restraining order prohibiting interference with peaceful marches. Three Illinois statutes used by police are declared unconstitutional.

1970

The U.S. Census reports the Cairo population is 8,277 and 43 percent black.

January Black citizens call on the Alcohol, Tobacco, and Firearms division of the U.S. Treasury Department to investigate the presence of illegal machine guns in Cairo. No action is taken.

February An International Association of Chiefs of Police survey of the Cairo Police Department is begun.

July 16 The federal court orders the city of Cairo to show cause why it should not be held in contempt for failing to protect black marchers.

July 23 A class-action suit brought in federal court against the state's attorney, the Cairo police chief, and the circuit court judge seeks to end racially discriminatory enforcement of justice in Alexander County.

August The International Association of Chiefs of Police survey finds the Cairo police "ill-trained and lacking in the necessary leadership and insensitive to the racial conditions confronting them." The findings are presented to the city council, then promptly suppressed.

August 8–15 American Nazi Party demonstrators hold a march.

August 9–12 Heavy shooting is directed against Pyramid Court, allegedly with illegal automatic weapons. On August 12, the shooting continues for four hours.

October 21–24	Pyramid Court and St. Columba Catholic Church come under heavy gunfire by both police and vigilantes.
October 24	Mayor Albert Thomas alleges that the police station was attacked by eighteen to twenty armed black "guerrillas." The story, subsequently disproved, is later retracted by the chief of police. Meanwhile, a state police armored truck is dispatched to Cairo by the governor in response to the alleged guerrilla incident.
November 5	All of the black police officers resign because of alleged discriminatory policies of the police department.
November 21	The International Association of Chiefs of Police survey, uncovered by representatives of the United Front and the NAACP, is released to the press.
November 24	A conference of state and federal law enforcement agencies with representatives of the United Front and the NAACP reach a nine-point agreement on law enforcement by the state police. The conference is boycotted by local authorities.
December 5	Cairo police and special deputies beat and arrest black picketers. The state police are conspicuously absent, failing to carry out the November 24 agreement to protect peaceful marchers.
December	A new class-action suit is filed to prohibit interference with peaceful demonstrators.

1971

January 21	Heavily armed state and federal agents begin a "weapons raid" on black homes, arresting many persons. The raid continues until well into the next month.
March 17	The circuit court rules that raid and search warrants were illegal, dismisses charges against those arrested, and orders compensation.
May 9–10	A new round of gunfire against Pyramid Court commences.
May 29–30	Pyramid Court and St. Columba Church are attacked with tear gas and gunfire; state police rescue three white movement supporters from the church in an armored car.
July 21	Seven black individuals file a civil lawsuit charging beatings and illegal searches of their homes.
October 24	State Police Supervisor Bill Reineking, a prominent figure in the illegal weapon raids in January and February, as well as other incidents of harassment of black citizens, is honored by the governor as one of the top state employees.

1972

March	A federal court of appeals hears arguments on a class-action suit against Cairo law enforcement authorities.
March 23–25	The U.S. Civil Rights Commission holds public hearings on

the status of civil rights in Cairo. The hearings focus on housing, employment, economic development, and administration of justice.

1973

February The U.S. Commission on Civil Rights issues its report, *Cairo, Illinois: A Symbol of Racial Polarization.*

October The U.S. Commission on Civil Rights issues another report, *Cairo: Racism at Floodtide.* Conditions reflected in the report remain unchanged one year after the hearings conclude.

December 31 The federal court orders the state court to dismiss all charges against black citizens arrested while conducting protest activities. The federal court also rules that a six-hour notice to police prior to holding a protest march is adequate, thereby allowing peaceful protests to be mounted soon after inflaming incidents.

1974

January 15 The U.S. Supreme Court rules that racial discrimination as practiced by the county judge and prosecutor cannot be the subject of review by federal courts.

May 13 A state appellate court finds racial discrimination in the hiring of black applicants by the police department.

October 17 The federal court orders the desegregation of all public housing, the hiring of more black employees by the housing authority, and the appointment of black representatives to the board of directors.

1975

June The Illinois Advisory Committee to the U.S. Commission on Civil Rights releases its report, *A Decade of Waiting in Cairo, Illinois.*

The state court orders the State of Illinois to compensate black citizens whose homes had been illegally searched by the state police. Seized weapons are ordered returned to owners and all charges dismissed.

September 2 The federal court orders that blacks be appointed as representatives to all city and county boards, commissions, and committees, in numbers consistent with their percentage of the general population.

1976

February 10 The federal court orders the Cairo Public Utility Commission to hire black workers and appoint black representatives to its board of directors.

February 27 The U.S. Equal Employment Opportunity Commission orders the City of Cairo to hire black workers in all of its agencies, including the police and fire departments.

1980
The U.S. Census reports the Cairo population is 5,931 and 43 percent black.

March 11 The federal court orders a change in the form of government from commission to aldermanic, to ensure the election of black representatives to the city council.

November 4 Two black representatives are elected to the Cairo City Council under the new aldermanic form of government—the first blacks elected since 1913.

1983
April Three black representatives are elected to the Cairo City Council.

1990
The U.S. Census reports the Cairo population is 4,700 and 55 percent black.

1992
June An all-white jury convicts a Cairo police officer of murder in the death of a black man, Roy Lee Jones, in December 1991. Jones, who was not armed and had not committed a crime, died of a gunshot wound to the back during a fourteen-shot barrage.

CAIRO, ILLINOIS, 1967~1973

A Photonarrative

So there's always two sides to every coin.

Every so often they will meet in the middle, but then it's for

different reasons as to why it comes together. Because you cannot

get an oppressor and the oppressed to agree from the same

point of view of what's happening.

—David Baldwin

Entering Cairo from the
north on State Highway 51.
September 1970.

■ *Out here at the baseball field, they had "colored" on one entrance. That never was supposed to have happened in Illinois. —AW*

Cairo was, basically is, a Southern town—it's closer to Mississippi than it is Chicago, and the attitudes from the South is here, the mentality of a superiority race, the lack of empowerment of the black community. In the '6os, there was places we didn't feel comfortable eating—they wouldn't allow us to eat. —CM

[Reading from a magazine interview with Cairo activist Hattie Kendrick:] " 'Have you ever heard of the 1965 Civil Rights Law?' Kendrick: 'No, it may be on its way, but it hasn't gotten here yet'"! —AW

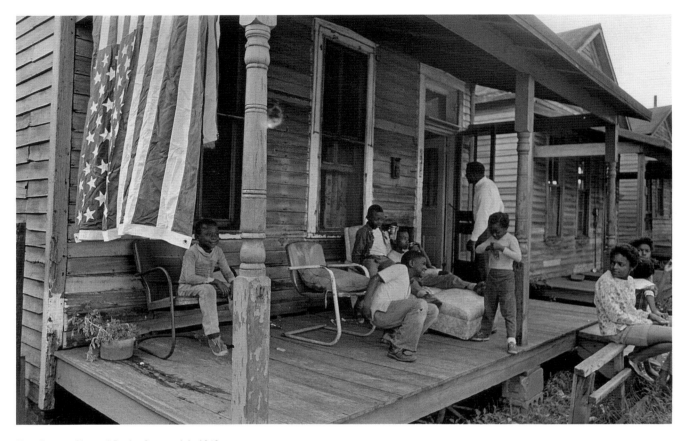

Row houses. 21st and Poplar Streets. July 1969.

■ *And here's another thing that annoys me. The American people, they send me a letter. Says, "Send us something to help restore the Statue of Liberty." I said, "My folks came—they came in the hull of a ship. They didn't see the Ellis Island. No Statue of Liberty." I say, "You wrote the wrong one a letter." —AW*

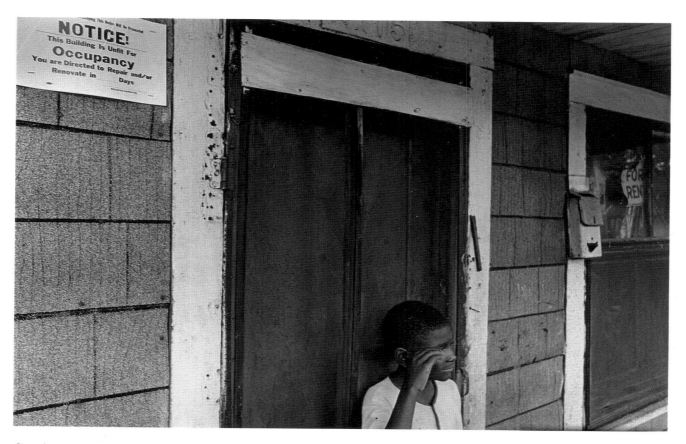

One of many condemned houses in Cairo. Site unknown. June 1973.

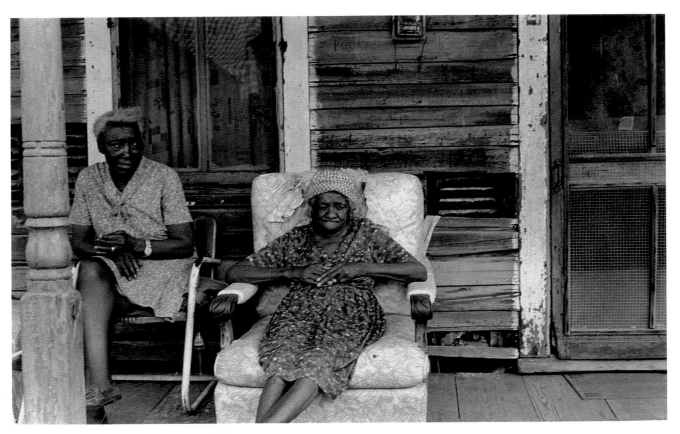

Row houses. 21st and Poplar Streets. August 1970.

■ *One time, they were talking about everybody out here was on welfare. But that wasn't the truth, because I wasn't on welfare. I think was only one or two people who were getting any kind of welfare. All the rest of us were the working poor. —AW*

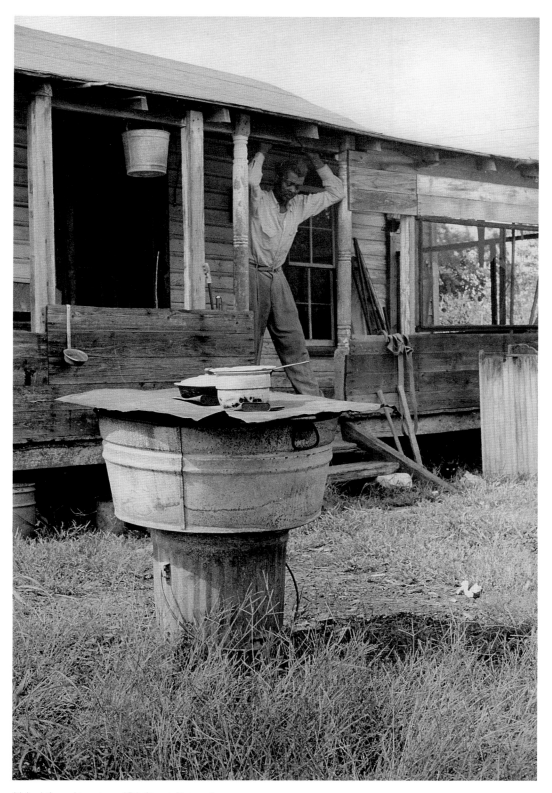

Makeshift cooking stove. 15th Street. Date unknown.

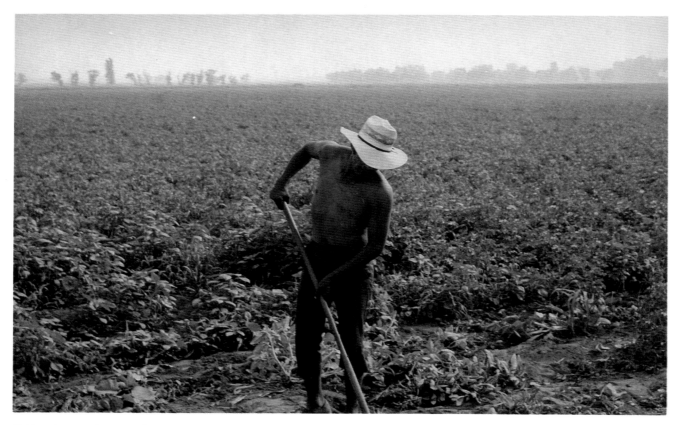

Field worker on a farm near Cairo. Date unknown.

Going to the field, chopping cotton, chop that man's cotton for ten dollars—no, we was getting five dollars a day, man. —CD

When I was younger—like, say ten, eleven, twelve years old—we used to go to the fields. My mother used to take us to the fields and pick beans. Every season there was something to do. In the summertime, you chopped cotton and chopped beans, and in the fall, you picked them. I've baled hay for two cent a bale.

I've picked cotton for three cent a pound, picked beans for sixty cent a bushel, strawberries for—I forgot how much we made a quart back then, but that's the only real work we could find in the summer, to buy school clothes and stuff. —CM

They locked out black people from being employed. They was the best jobs in town, the public utilities. The Cairo Utility Company is probably right now one of the best paying jobs in Cairo.

And the stockholders of that Cairo public utilities are the people of Cairo. It's public owned and operated. Those jobs was strictly for white people. Fire department—blacks was locked out of that. Not hired or trained for that, until the court said they had to do it. —CM

It was the thing where if you really wanted to work, you could work, but the thing about it, you understand—we wanted not only just jobs; we wanted jobs with

some kind of substance. You know, like where we could see somebody moving up ahead, trying to do something better, where everybody was proud. —CD

They said to Mrs. Long's son, "Have your mother make some cupcakes." And Linda, my daughter, said, "His mother doesn't make those cupcakes. My mother does." —AW

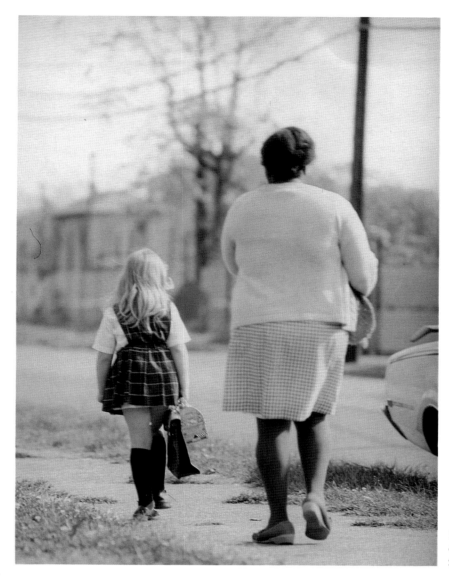

Maid walks her employer's child to school. Walnut Street. October 1968.

Oh, we couldn't go to the Laundromats to wash our clothes! We had to wash them at home. That was the strangest thing—some of the people would bring their clothes to people out here to wash them and iron them. But they didn't want them to go to the Laundromat and wash their own clothes. If I was washing for you, you brought me the clothes, you wouldn't know if I put some of mine in the tub with yours, would you? —AW

If I had desired to quit [domestic work] I could have quit. But I had children. I wanted to be at home when they went to school. Because I wanted them to be at school everyday. See, if I got up and went to the factory, I wouldn't know whether they went to school that day or not. That was one reason I kept the job. I didn't get as much as I would have gotten if I had gone to the factory. —AW

We had a meeting up at the courthouse. It was before it burned down. They wanted to know what we wanted. We say all we wanted was economic opportunity. We made our own social opportunity. All the people you know, you don't associate with. But if you have a decent living, you can do whatever you want. Why should I have less because I have a different color skin? I'm American, too. —AW

■ Because what happened, they hung—they hung—my first cousin here, in jail. Robert Hunt. And he was like a brother to us. He wasn't the type to commit suicide. They say he hung his self with a T-shirt, which we knew wasn't so. We went and viewed the body at the funeral home, and you could see where he had been beaten, seriously beaten, and we know he didn't hang his self with a T-shirt. We don't know if he was beat to death or later they hung him. —FS

They had a jailer during that time that was there, that's supposed to have seen and knew what happened. They paid him to leave town. We never seen or heard from him anymore. And he was a black guy. —FS

They even took him out and had the local undertaker embalm him so we couldn't do an autopsy. The next day they did it, within twenty-four hours. —CM

The coroner was on they side. . . . Just like when Percy's son got killed, that runs the tavern uptown, the police officer supposedly had gotten ten years. I see him driving around everyday. If I had went out there and shot somebody like that, man, I probably would have got life, you understand. —CD

They hurried up and broke down with curfew. You had to be in at a certain time. But still, we had violent people out there. As long as they didn't get caught, they was out there. So I am not sure which side was starting it or none of that. But I do know that it happened. And we felt that it was a big lie that was told here in Cairo. —FS

When I got back home to north Cairo, they wouldn't let me come to town that night. The Guard was here and I called home because I was kind of frightened. And my son said, "Mama, we not scared now, because the National Guard is here." My sister Ruth saw them on TV. And she called all the way from Chicago to tell me to go back in the house! Then they started the White Hats. You had to be here, too. You couldn't even imagine it! Just somebody telling it, it doesn't seem real. It seems like something made up. But it actually happened. Now it's been such a long time ago. But you think about it sometimes and you get an eerie feeling down your back. —AW

It was answering a call of a bell that had been ringing for years and years and years and nobody responded to it. So in a sense that particular time, for that instance, an awareness just erupted. That was a typical example of all the attitudes of the country at that time. —DB

Memorial to Robert Hunt by Preston Ewing Jr. in the *East St. Louis Monitor*. July 6, 1968.

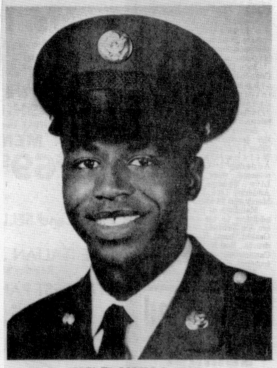

ROBERT HUNT MEMORIAL TO BE HELD JULY 11

PRIVATE ROBERT L. HUNT

A special memorial program in honor of Private Robert L. Hunt will be held on July 11 during the Black Solidarity Day in Cairo.

Private Hunt was a black soldier that was hung in the Cairo Police Station late in the evening of July 15, 1967 after being arrested by the police while riding in a car with friends that hot and humid Saturday night.

Members of the Cairo Police Dept. alleged that Pvt. Hunt hung himself with an under shirt that friends said he was not wearing because of the hot weather. The story of the police never accepted because of the well known practices of brutality of the policemen that surrounded his death coupled with the secret manner in which the matter was handled after his death became public.

An examination of the cell in which he was said to have taken his life indicated that it was impossible for him to have hung himself in a manner described by police. The inquest into his death was not held for two months and immediately after it, the coroner quit his post.

Blacks reacted to Private Hunt's death with indignation in the face of clear evidence that he had died as a result of foul play by members of the Cairo Police Dept. His death was immediately followed by four days of fires and shootings in Cairo. Peace was restored after the Mayor and Ctiy Council of Cairo made seven promises to end racism in the fire department, police department and other city controlled agencies. To this date none of the promises have been lived up to and they continue to be the demands of the black community.

After calm returned to Cairo in July of 1967 the White Hats came on the scene and began their acts of terror. Their activities have continued and they continue to be the source of radical troubles in the community.

The NAACP says that it made the decision to honor Pvt. Hunt because he was killed by white racists and because his death cau ł the cup of the black con: to runneth over.

Relatives of Pvt. Hunt will be presented with a plaque in memory of him.

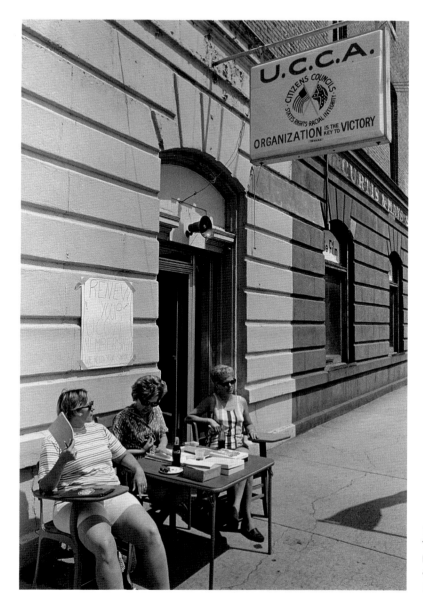

Membership workers at the White Citizens Council headquarters. 8th and Commercial Streets. July 1969.

■ The White Hats community group—the men given the legal authority to carry guns and citizen band radios—it was called White Citizens Council and it was called the White Hats, also. —CM

I tried to look at them as being people trying to protect their communities. They thought violence was going to come up. In their area, you know—their part of town. But as they started riding around with police powers and having radios and guns and stuff

like that, I didn't really like that. I felt intimidated and I felt afraid to be caught in a certain area uptown, because I could be intimidated by those people. —CM

They were at the concession stands at basketball games and things. Sometimes they'd even have their white hats on there. —AW

If you were caught, say, in the area of St. Mary's Park—that's primarily where most of your

affluent whites live—alone at night . . . Those people riding around in their private civilians' cars, they could easily get up on you and do something to you, and I didn't want that to happen to me. I didn't want somebody to think I was going to do something, to burn or break into something. —CM

There was something, a code they used—if violence was going down in Cairo or anywhere in the area. This radio station would travel from Cairo to Anna, and that

was like a backup system in case things got out of hand or things went rampant, murder and burning and all this. The White Citizens Council stretched all the way into Anna, like a reserve or backup group for whites in Cairo: "If we need you, be there. Or if they get rampant and running out of town, out our way, let us know. All interstates and highways—we'll be out there to support the law." —CM

ATTENTION!

WHITE CITIZENS COMMITTEE
WILL HOLD AN
ORGANIZATIONAL MEETING
TONIGHT AT 7:00 PM
AT
ST. MARY'S PARK
PROTECT YOUR LIFE AND PROPERTY

Flyer distributed throughout Cairo. Date unknown.

You know this used to be the stronghold of the Ku Klux Klan, man? Right here. Especially out at Thebes. Now, they gradually moving blacks out there, but look here—Thebes and Olive Branch, all up there used to be the stronghold of KKK. And I ain't afraid to say that. You better not get caught out there in Thebes. Back then you'd end up on a tree or something, floating down the river. —CD

The levee area sitting on the backside of the housing projects— they would get up on the levee and cars and they would shoot into the projects. The projects would shoot back out. Who started it, you can't really tell, but you know that those—what they'd call vigilantes, I call them White Hats or citizen patrols— shouldn't have been out with weapons doing that. And gave them police powers—I think that was real bad, that was the center of a lot of problems. The blacks felt that, hey, you know, like back to the Klan days. —CM

WESTERN UNION TELEGRAM

CP18 (B KMA174) PDB KM NEWYORK NY APR 7 345PEST

PRESTON EWING JR

 513 23RD ST CAIRO ILL

THE FOLLOWING TELEGRAM SENT TODAY TO GOVERNOR OF ILLINOIS.
QUOTE. STATE'S ATTORNEY AND SHERIFF OF ALEXANDER COUNTY
AND CHIEF OF POLICE OF CAIRO PUBLICLY STATE THEY PLAN TO USE
SO-CALLED WHITE HATS IN CAIRO TO ASSIST LOCAL LAW ENFORCEMENT
OFFICIALS. THESE STATEMENTS APPEAR TO GIVE LEGAL OR OFFICIAL
STATUS TO AN ALL-WHITE VIGILANTE HATE GROUP COMPARABLE TO
THE WHITE CITIZENS COUNCILS IN THE SOUTH. EQUALLY REPRE-
HENSIBLE IS FACT THAT THESE PUBLIC STATEMENTS BY LOCAL LAW
ENFORCEMENT OFFICIALS ARE INFLAMING AN ALREADY TENSE COMMUNITY
AND MAY ENCOURAGE EVEN GREATER VIOLENCE. WE STRONGLY URGE YOU
TO MAKE IT VERY CLEAR THAT LAW ENFORCEMENT IN CAIRO DOES NOT
MEAN EXTRA-LEGAL ACTIVITY BY A PRIVATE GROUP
 ROY WILKINS EXECUTIVE DIRECTOR NAACP 1790 BROADWAY
NEWYORKCITY

349PCST

TELEPHONE _____ 1387
PHONED TO _4-7_ _412PM Nof ho_
TIME DELIVERED _____ _will return_
BY _____ TO BE
ATTEMPTS _____

Telegram from executive director of the NAACP to Preston Ewing Jr. April 7, 1969.

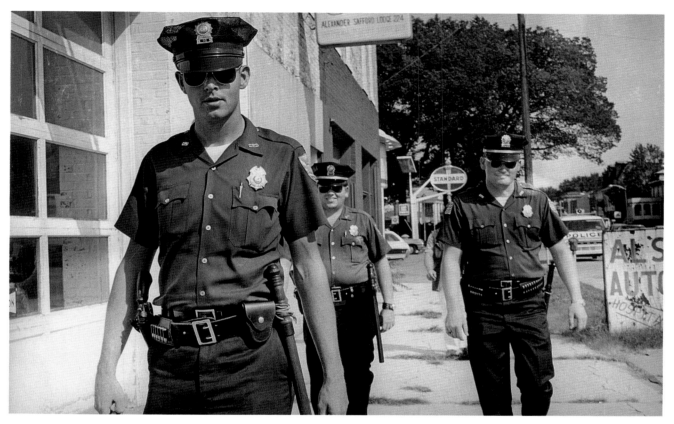

Cairo police officers. Washington Avenue at 7th Street. June 1969.

[You couldn't call the police]
because they were part of it—
they were cops of day and White
Hats at night. It really got to be
just a war zone. —DB

I warned the young men. I said,
"Nothing I can do but open my
door if they get too hot for you."
—AW

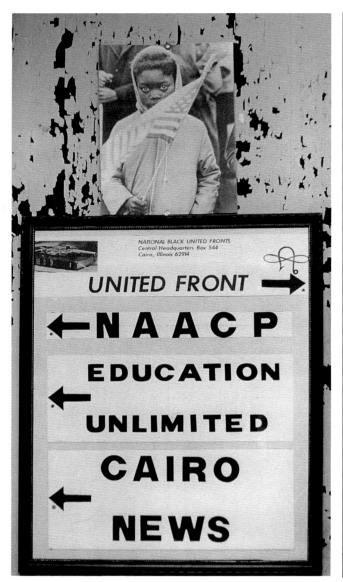

Directory of offices of black organizations. St. Columba School building. April 1969.

Cairo NAACP Adopts 30-Point Program For 1968

Due to the many discriminatory practices that black people in this county are still subjected to, the Cairo Branch of the National Association for the Advancement of Colored People dedicates itself to the following program during 1968. We will work to:

1. End illegal and unjust practices of the Cairo Police Dept.

2. Have racist policemen removed from their position.

3. End racial discrimination against black students in the Cairo Public Schools and the Egyptian Public Schools.

4. Have the name Booker T. Washington restored to the so-called Bennett Elementary School.

5. End unjust treatment of black people by the Illinois Department of Public Aid and the Alexander County Office of General Assistance.

6. Establish a form of news media through which black people can speak.

7. Destroy the evil system of vote buying.

8. End unjust practices against black students and teachers at the Cairo Vocational School.

9. Withhold the money of black people from any and all places of business that do not employ black people.

10. Establish and support a black economic program controlled and executived by black people.

11. End racial discrimination in every area where such practices are prohibited by law.

12. Have the so-called Urban Renewal Program revised in such a way that black people will be assured of securing decent housing as a result of having to sacrifice giving up their present homes.

13. Have the local Poverty Program completely changed in a manner that it will truely meet the needs of the poor people.

14. Stop all forms of exploitation of black people by whites.

15. Organize the black people politically.

16. Neutralize all Uncle Toms and Aunt Suzies.

17. Destroy illegal practices in the courtrooms.

18. Make good, honest legal representation available to black people.

19. End segregated use of St. Mary's Park baseball field.

20. Insure black participation in all programs whiere federal money is being spent.

21. End the military drafting of black boys by the all-white draft board.

22. Make city offered services (such as street cleaning) available to black areas on a basis equal to those now being performed in only all-white or integrated neighborhoods.

23. Make free textbook available to the students in public schools.

24. Develop a housing program that will provide good housing for black people.

25. Provide recreation facilities for the youth of Cairo, Future, Klondike and Sandusky areas.

26. Have the history of black people taught in the public schools.

27. Get more black people involved in the struggle for freedom.

28. Create a council with representation from all black organizations in this county.

29. Strenghten the Branch in all ways that will enable it to fully assist the black people in their efforts to destroy the system of ungodly racism that they are the victims of.

30. Set the white community free from its religious attachment to their system of racism that has destroyed this county economically and morally to such a degree that it may never recover.

Community News

By WILLIE BINGHAM
ADMINISTRATOR AND
COMMUNITY EDITOR

The students of the I.M.C., G.E.D. are very proud with the progress that the class is having. One more important thing is that the class has agreed to pay a week savings of twenty-five cents (25¢) in order to pay for the GED test. The students of this section also have elected class officers, they are as follows: Willie Bingham, Chairman; Charles Mitchell, Vice Chairman; Bobbie Hollis, Secretary; and Mrs. Bradley, Treasurer. The Instructors of the GEC class are Mr. Farmer and Mr. Joyner.

BULLETIN-
It was brought to the attention of the buying club, that distribution of the food will be changed from Friday at 2;30 to 5;30 to Saturday, from 12;00 Noon to 4;00 o'clock. Orders must be in by Wednesday at 3 o'clock in order to meet the deadline.

EWING GETS SIGNAL APPOINTMENT

Preston Ewing, Jr., President of the Cairo Branch of the NAACP (National Association for the Advancement of Colored People), has been appointed to the Illinois State Advisory Committee to the United States Commission on Civil Rights.

The Commission made the appointment at its January meeting in Wash., D.C.

The Illinois State Advisory Committee assists the U. S. Commission on Civil Rights by holding public hearings on complaints of racial discrimination and collects information concerning legal developments constituting a denial of equal protection of the laws under the Constitution of the United States.

The Committee held a hearing in Cairo in June, 1966 and it was after that time that the black people began their push to eliminate the many discriminatory practices they were being subjected to.

Mr. Ewing also serves as a vice president of the Illinois State Conference of the NAACP Branches and Regional Director of the Southern Illinois District of the Illinois State Conference of NAACP Branches.

Announcement of a plan of action by Cairo chapter of the NAACP in the *East St. Louis Monitor*. February 1, 1968.

■ The NAACP was working from the standpoint of laws being changed. But it's like any other institution: it can be overburdened with the paperwork and then try to deal with the physical structure also. So you have to have someone, the soldiers, rather than office personnel. The NAACP could have been the head, the [United] Front could have been the arms, SNCC [Student Nonviolent Coordinating Committee] could have been the feet. —DB

What was happening was that the people were beginning to see police brutality, just at random. Then we saying, "We better organize, get something together here, we got to defend this." So look at the grass-root element. More or less what happened from that point was all these clergy got together and they came up with the idea of the United Front. The way they had it was that it would be an umbrella of various organizations throughout the state and country, which it did eventually become. They were developing all over simultaneously. But you got to remember, Cairo was about the last area to jump off into the racial scene of rebellion. —DB

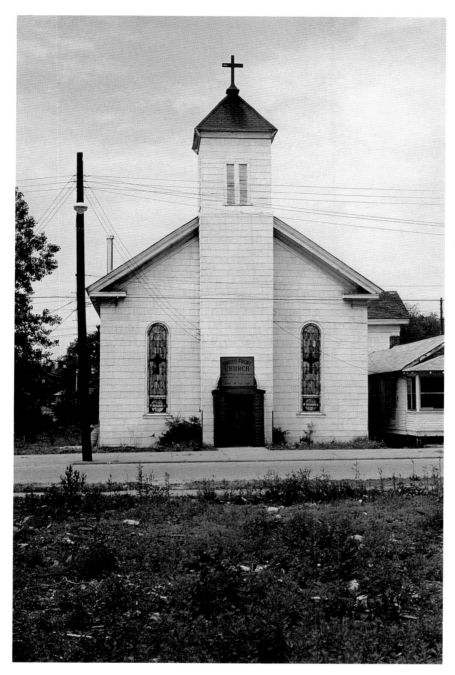

St. Columba Church (also called the United Front Church during the movement) on 14th Street. Summer 1970.

The United Front was everybody in the community. Like, when you hurt one of us . . . You know, that's what a united front is. It consists of the whole peoples. Uptown, downtown, and everywhere. —CD

They didn't realize the resources of a people who had never had an opportunity. We don't need anything to make something. —DB

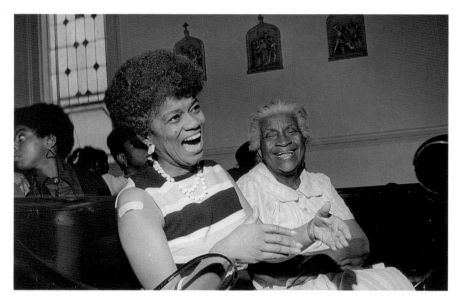

Hattie Kendrick (on the right) and Charlotte Brooks at a civil rights rally. St. Columba Church. April 1971. In the 1940s, teacher and community leader Kendrick, represented by the young Thurgood Marshall, brought Cairo's first major civil rights lawsuit, which targeted pay inequities between black and white teachers.

■ *At St. Columba Church, we used to have rallies, we used to get an old van and go around with our speakers and pass out leaflets. The church be packed all the way up to the rafters, because we had a bell that we would ring in the church. The people—old folks, they'd be walking, everybody be walking, people be pushing their babies. We had a brother named Reverend Rice Whitfield. Then his brother, Herman Whitfield, and all the Whitfields and the Martins. Then we had the Branns. All of them would be up there and sing and then they would rock the church down, man! They start singing them old Negro spirituals, you know—"I ain't gonna let nobody turn me around." One Saturday they'd always give you inspiration to make it to the next Saturday.*

It wasn't nothing about—when, like ordinary church, they'd be telling about the pie in the sky— it wasn't nothing like that. It was talking about survival—survival from one week to the next week. —CD

You had Mama Martin, sister Geneva Whitfield. You had many sisters that spoke out dearly, you understand, about the struggle. Sister Martin, she was a strong black sister. She spoke out about all the injustices. She'd get up on the podium to speak. There was a lot of black sisters that got up and spoke. —CD

There's some real strong women back then, that was real concerned and involved. We had an older lady by the name of Hattie Kendrick, which is very strong and very—I mean, I just can't say strong enough. She was very intelligent, very educated and had a very strong mind. She was probably one of the strongest leaders we ever seen in Cairo— male or female. Miss Hattie Kendrick. School teacher involved with the NAACP, she fought discrimination back when schools was segregated. She was very much concerned about schools being integrated and fairness in the school system. She knew that was our future. —CM

There's one beautiful thing that I've always remembered: the church itself was very supportive. They were part of the spiritual nucleus of the movement. —DB

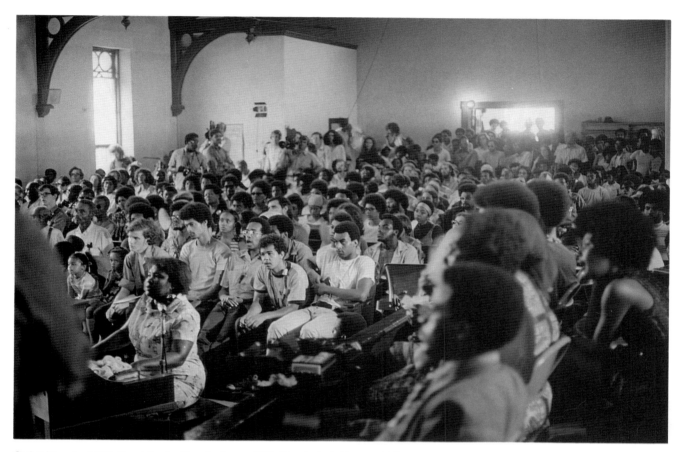

Civil rights rally at 12th Street Baptist Church. August 1969. The pianist is Hernean Mallory.

The room was just full, and I
stepped in the door and I said,
"What am I doing down here?"
It was so many. . . . I didn't
know why I was there. But I
know I had to be there. —HM

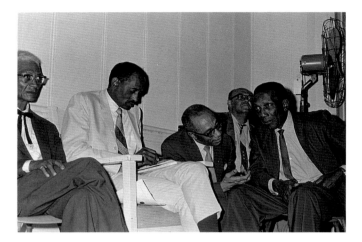

Local ministers at one of the
weekly rallies held at St. Columba
Church. May 1969. *Left to right*:
Levi Garrett, Blaine Ramsey,
D. Staples, M. T. Harrel, Sherman
Jones.

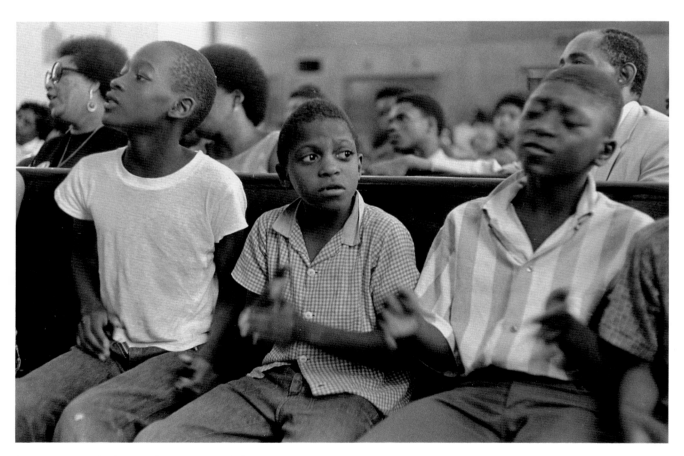

Civil rights rally at St. Columba Church. August 1969.

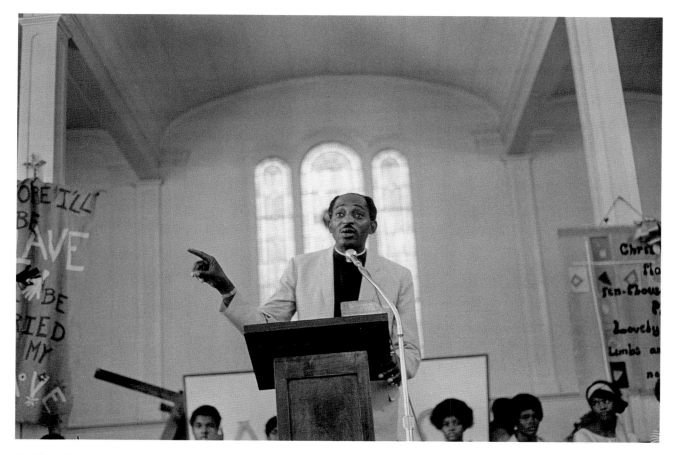

Rev. Blaine Ramsey, a local minister, speaks during rally at St. Columba Church. February 1969.

The church was the control center for the movement in Cairo. This is where the rallies were held, marches were organized. Feeding people. Clothes and food were brought in from other communities throughout the country. Speakers, entertainers came down, gospel groups came down. Jesse Jackson even came down one time and marched. So the scope of the problem in Cairo was expanded throughout the country—from St. Columba Church. This is where we turned out after the rallies—very excited and energetic to march—after sermons from Reverend Koen and speeches from different people throughout the community. —CM

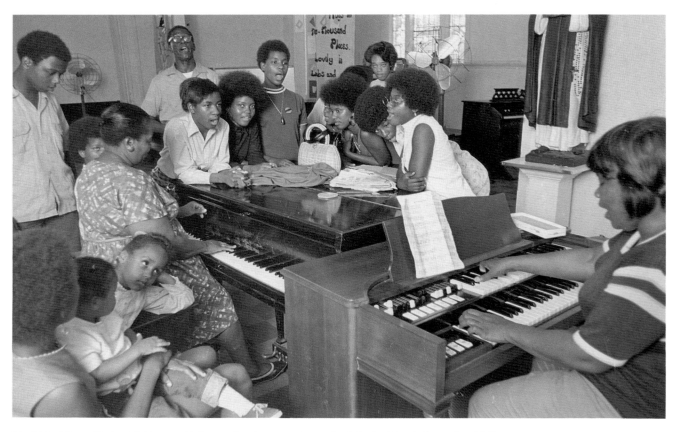

The United Front Choir, with Hernean Mallory at the piano, practices at St. Columba Church. September 1969.

■ *I walked in and I was in the middle of the building, standing, looking all around, and Reverend Koen was up there and he said, "Aunt Hernean, what are you doing down here?" I just said, "I come to help. What you want me to do?" They was trying to get a* *choir together. He said, "Can you play for this choir?" I said, "I'll try." I've been playing since I was three, because that was from the Lord. And that was the beginning of getting the United Front Choir together. —HM*

We would sing songs that would tell a story about the struggle, survival, about God. I remember they had a big speaker that they would sit where my voice would go out—I thought about it today and I kind of cried a little bit. —HM

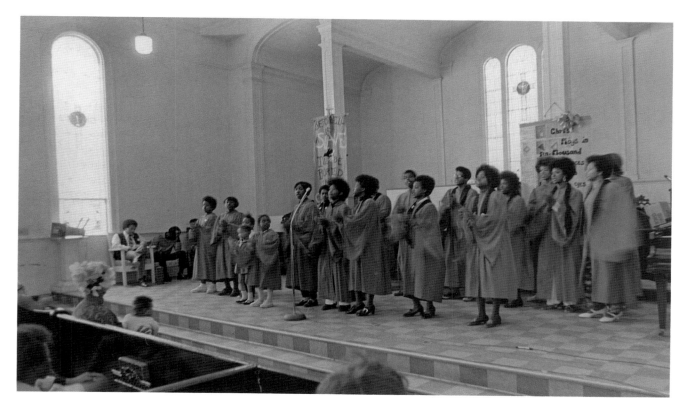

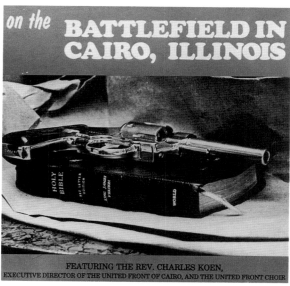

The United Front Choir performs at St. Columba Church. Date unknown.

Cover of record album of civil rights songs performed by the United Front Choir. February 1971.

Then on our records we had a gun and a Bible. That gun was for your sure-enough protection, and that Bible was for your direction. —CD

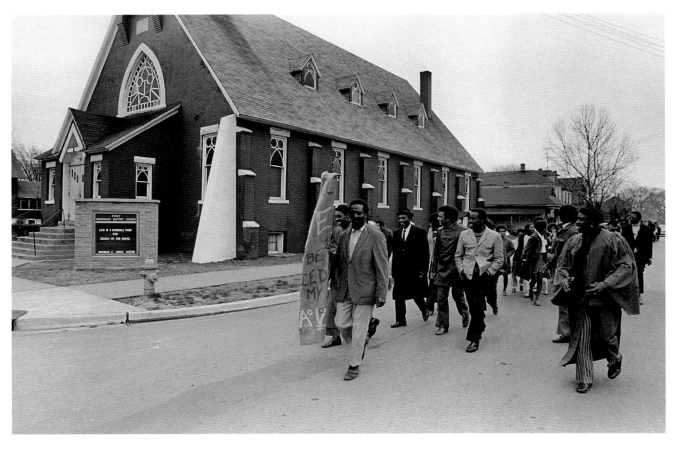

Marchers leaving rally head downtown. 12th Street Baptist Church. January 1969.

■ *Every Saturday we had a rally. We had pickets every day. I would picket some but not as much, because I had to work. But I would definitely go out and march on Saturday. It was probably take two hours to leave St. Columba Church and go downtown into the business district and back, through the housing project and around, picking up people as we go and back around to the church. Sometimes we would have a meal, and sometimes we would just sit around and talk and strap—you know, talk about what was happening and what was going on—plans.* —CM

They had the state troopers to come in and direct; nobody was ever disorderly or anything in the marches. They just marched. —AW

The kids really ate the rallies up, and the marching, because of the excitement. The kids in the housing projects, they really knew what went on because they were the ones that slept under the beds during shootings, slept in the bathtubs, stayed up all night listening to their grandfathers. So they knew what the movement was all about. Twelve-, thirteen-, fourteen-year-old—we'd take them down to picket and let them know what they were really

picketing for. Because you grow up, you can't get a job at this store, and your dad and mom can't get a job, your sister can't get a job in this store. —CM

We had older people's support. We had older people that were frightened to death for it. They didn't know what to think or do. Because at some point it makes you wonder, is we dreaming? Wake us up. What's happening here? —FS

The older people felt that you're going to get killed, or they're going to hurt you. Because they remembered the lynching days and the burning days and the

real violence. They might call you on the phone and say, "Come by and get ten dollars to turn in to the rally, but don't tell anybody." Or, "I got a couple of pies here or some turkey and dressing, chicken and dressing, or collard greens, or beans or something to take down and feed the people. But don't tell them. You don't have to bring the pot back. Don't tell them that I gave it." They was afraid, because they was on social security, or aid, and they figure, "They'd cut me off." Your utility bill get cut off. The town was poor back then; it's poor now, but it was worse then. There was no black middle class. Everybody depended on the white people for everything. Most people

March passes through local neighborhood. 12th Street. January 1969.

depended on the local grocery stores and people buying on credit to get food. You go in and get your weekly allowance of groceries and pay once a month. If you were caught demonstrating, you couldn't get it. They wouldn't tell you, "Because of the rally." But they would tell you, "I can't extend you any more credit." And you got the message; you got the message loud and clear. —CM

I felt great. I held my head up high. We were marching for something we thought was right. It was a great feeling. To march through town and let the white folks know we were somebody and look at us for a change! . . . I was in every march that ever walked. Right there every step of the way. —FS

Oh, I remember this. It was so many thousands of people came—white and black—they made a circle around Seventh and Eighth Street, and they was still coming. I looked back; as far as you could see was people. I ran to the corner of Eighth Street. I stood on the corner and said, "Mighty Power!" It was something to see! And they was still coming. —HM

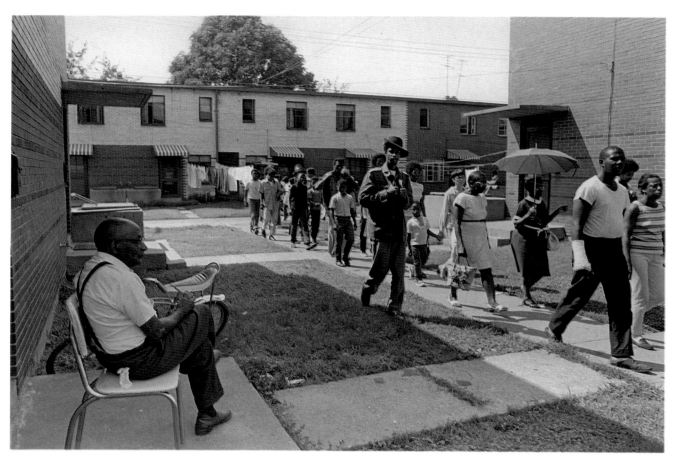

March passes through Pyramid Court public housing complex. August 1970.

Illinois state police officer watches marchers approach downtown. Washington Avenue and 11th Street. February 1970.

[Singing:] "Just a-walking and talking with my man set on freedom, allelu, allelu, alleluia." There were lots of them. Just like when we'd be walking on the picket line, we used to sing this all the time: "I ain't gonna let nobody turn me around, turn me around, turn me around." Then we'd change it up and say, "I ain't gonna let Mr. Charlie turn us around, we're just gonna keep *on walking, keep on watching." It was songs like that which kept us motivated, especially when we would have them marches through downtown. Then you see the White Hats; they'd be on top of the roofs with guns. You just can't imagine how beautiful it was, to know that black people did come together. —CD*

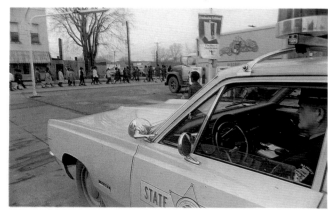

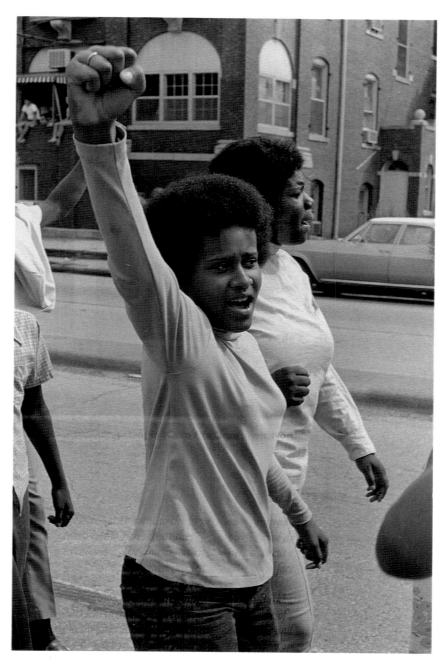

Protester Acquanetta Martin salutes. Downtown. July 1969.

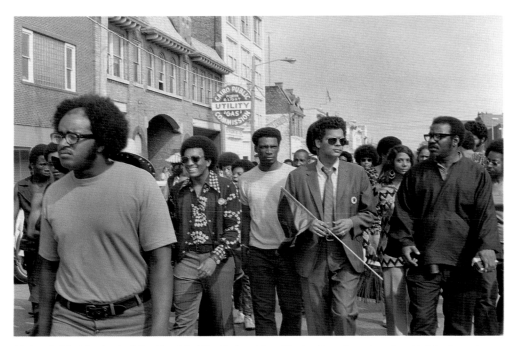

National civil rights leader Julian Bond (holding flag) and Rev. Charles Koen (wearing print shirt) lead march. Commercial Street. July 1971.

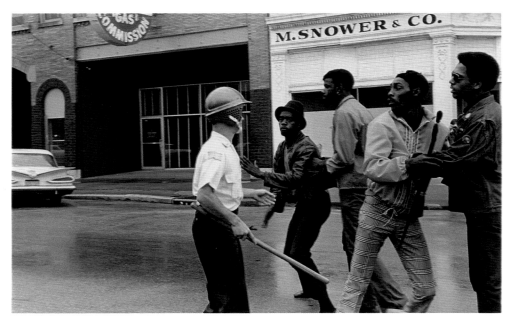

Confrontation between police chief and protesters. Commercial Street. March 1970. *Left to right*: Chief Roy Burke, Randy Robinson, Ezell Littelton, Herman Whitfield, Cordell McGoy.

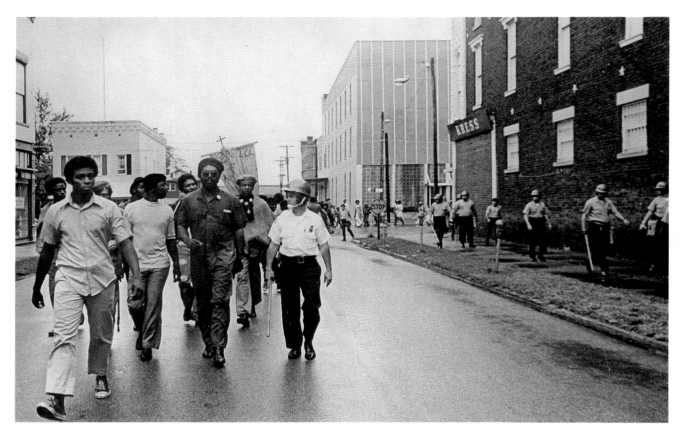

Marchers encounter police. 10th Street. July 1970. *Foreground, left to right*: Ronnie Garrett, Russell DeBerry, Frank Washington, Chief Roy Burke.

■ It was really kind of terrible to see the citizens—white and black—fighting for something that we should have been sitting down sharing and talking about way before this happened. There was no preparation, and it just exploded down there one day. I thought, "If we don't get a grip on this thing, we're never going to be able to live or work together or get along." —CM

Well, one night the cafe was crowded. And [then] looked like the whole of Future City lit up! We didn't know what had happened. We went to the door and the Klan—we called them Klan —put a cross. The man ran off and left his truck. Left his truck! He sure did, honey. I guess he came back and got it, but he sure left it then! We took that cross down. Put it out and brought it on in Future City. . . . There was a time when they burned one out there at the Pyramid Courts. They had the sheets on that time! —HM

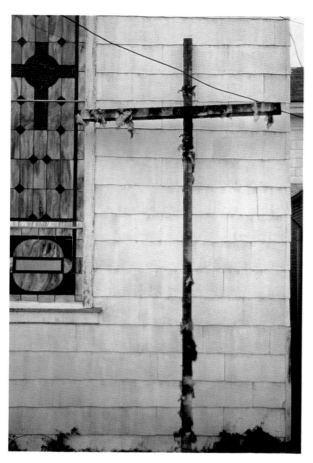

Remains of a cross burned in front of St. Columba Church. Date unknown.

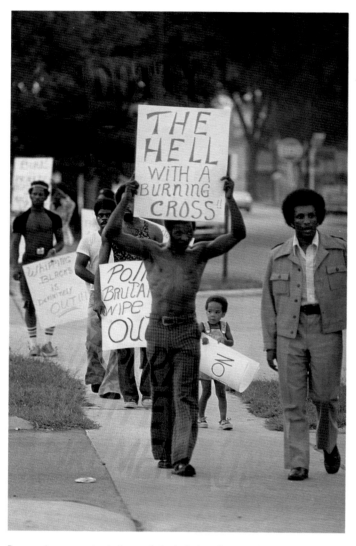

Protest demonstration in front of city hall after the cross burning. Date unknown. *Foreground*: Ernest Morgan (holding sign), Rev. Charles Koen.

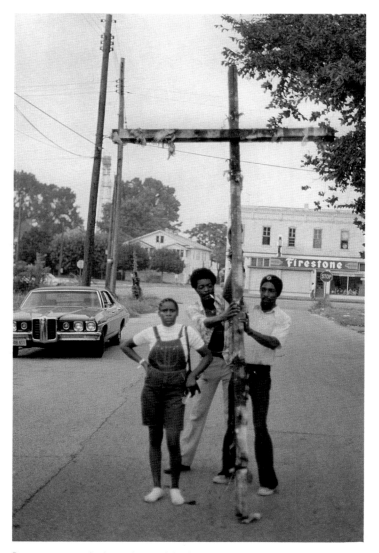

Protesters carry the burned cross. 14th Street. Date unknown.
Left to right: Maquita Whitfield, James Chairs, Herman Whitfield.

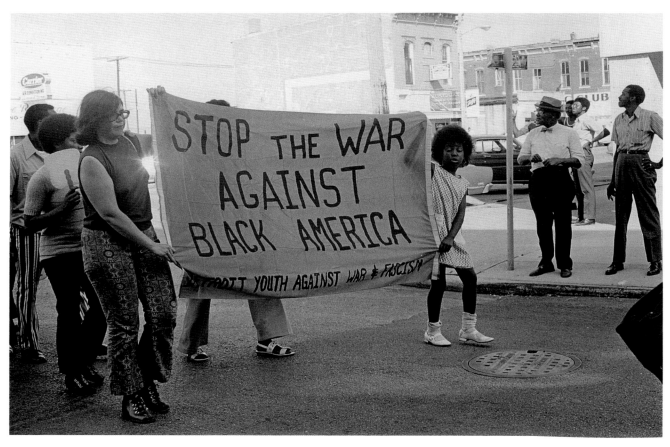

Out-of-town supporters join local protesters in march. Downtown. June 1972. *Far right*: Preston Ewing Sr. (wearing hat), Walter Hill.

Local supporters Tony Harris (on the left) and Joyce Gilky in front of St. Columba Church. July 1970.

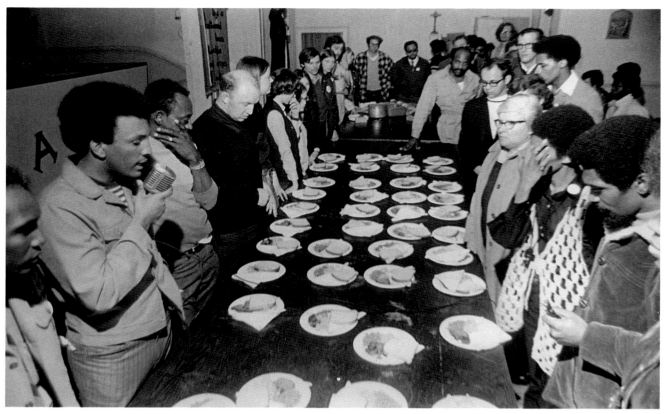

Rev. Charles Koen leads the prayer before a meal. St. Columba Church. Date unknown.

Poster for one of many gatherings where national civil rights leaders and out-of-town groups came to support the local movement. 1974.

When we'd leave, you were so filled up with spirit. And you carry that all the way down the march with you. We might have a little devil in us when we come back, because the people done provoked us to get an attitude. But we go ahead on and eat that off, because we always had food prepared for the marchers when we came back. So that's the way that was dealt with! —FS

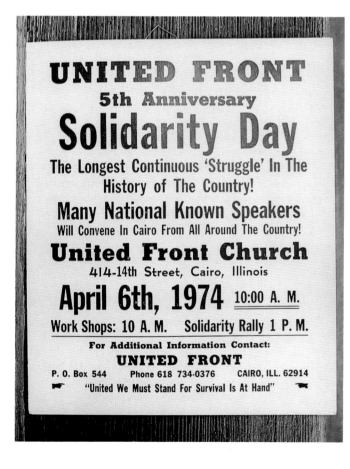

UNITED FRONT

5th Anniversary

Solidarity Day

The Longest Continuous 'Struggle' In The History of The Country!

Many National Known Speakers
Will Convene In Cairo From All Around The Country!

United Front Church
414-14th Street, Cairo, Illinois

April 6th, 1974 10:00 A. M.

Work Shops: 10 A. M. Solidarity Rally 1 P. M.

For Additional Information Contact:

UNITED FRONT

P. O. Box 544 Phone 618 734-0376 CAIRO, ILL. 62914

"United We Must Stand For Survival Is At Hand"

■ The boycott was very effective—it was steamed—because they wouldn't hire minorities downtown, in the department stores. So blacks felt the only way they could change that was not through violence but through peaceful demonstrations, by not shopping in those businesses. Making up forty percent of the population at that time, and having a spending power, it would hurt the economy of Cairo, and so the whites would break and open up. But that didn't happen. They would rather go out of business than let blacks in. You can see why we don't have a downtown anymore. As a result of the boycott. —CM

They would bring people from Kentucky and Missouri, rural whites to work in the factories here; we couldn't get jobs. Those were very hard things for me, very confusing things—I couldn't understand why you didn't want your own community working and drawing a paycheck to spread it around, instead of having someone come in and take the paycheck and take it home. —CM

It wasn't so much the jobs but the attitudes towards parents and customers during that period. My parents and a hundred more who had X number of kids was really the main backbone supporter of your business. But by your attitude and your way of saying, "Hey, I don't need you or your

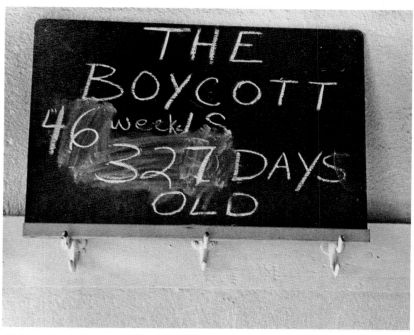

Chalkboard at NAACP office. March 2, 1970.

dollars, but I'm going to take it anyway. I can treat you any kind of way because you ain't got no other." —DB

This was before J C Penney left. I went in the store. I was going to buy two coats, some shoes, and socks. And this man and saleswoman just kept talking, kept talking, kept talking. So finally the manager say, "Wait on this lady if she wants something." Then he chewed this lady out. He said, "These other people go to St. Louis, Memphis, Chicago to get their clothes. The only way we're going to stay in business is to wait on people who has to buy here." But pretty soon they went out of business. I guess they didn't pay him any attention. —AW

They looked at you as if you were coming in there to steal or something.—CM

After we initiated the boycott, we had people sending food in, clothing, everything. We didn't have to

shop there. We got rides to take people out of town to shop. That was the most important thing that we did back then. We formed a "Freedom Ride" cab, where we take people back and forth to stores, go and help the elderly people get their groceries. —CD

We didn't go downtown. The only thing I had to pay down there was my telephone bill, and I mailed that in. I had two girls in college and I couldn't have gone downtown anyway! So, I supported the boycott: it was because of lack of money! —AW

There's always built-in safety mechanisms for people within the system and protected by the system. You are allowed two federal loans to stimulate your business till it gets back on its track. Now, as long as they didn't have to bother that, they wasn't upset, because they knew they had a cover, they had protection. "After about thirty days or two months,

the thing cool down." But then it went six months—"Well, don't worry, they won't last a year." Then it went a year. But their point was to prove they didn't need black business, black monies, downtown—which in reality, we all know that white didn't support downtown, no whites. Most of the time when they went shopping, they would go to Cape, Sikeston, Paducah, but they never shopped downtown. The reality was that what kept the lifeblood in downtown was my mother and a lot of other black mothers in this town. —DB

Some of the merchants wanted to break before the boycott was over. Some of the merchants wanted to hire blacks. But the retail merchants in the Chamber of Commerce was so racist and so strong against this movement that they said, "We can't give in to these niggers. . . . Give them an inch and they'll take a mile." So they didn't. —CM

It didn't have anything to do with we ran them out of business. Theirs was, they had a principle they stood by, and ours was, it's unconstitutional. —DB

The picketing, I guess, began to cease in '71, to take a different connotation, because by that time there wasn't anything downtown to picket; all the businesses had closed. It had accomplished a goal—but a victory, no. Because everybody lose in a situation like that. Nobody wins. —DB

Proclamation

I, Leo P. Stenzel, Mayor of the City of Cairo do hereby proclaim that in my judgment that a civil emergency exists within the corporate limits of the City of Cairo, Illinois, as of this date. Pursuant to this proclamation of civil emergency I hereby issue the following order:

1. Effective immediately all gatherings of people of two or more individuals is prohibited.
2. It is further ordered that no person shall take part in or become a part of a parade or engage in any picketing within the corporate limits of the City of Cairo.
3. No person shall loiter in and upon any public street within the corporate limits of the City of Cairo.
4. This order shall be effective immediately and shall be in full force and effect until recinded by further action on my part.

Dated at Cairo, Illinois, this 11th day of September, 1969.

Leo P. Stenzel
Mayor

Proclamation issued by the mayor in the *Cairo Evening Citizen*. September 11, 1969.

■ I had six children, and Flora had about nine. I said neither one of us could have taken all our children one time for a pair of shoes, because we would have formed a parade! There was so much stupidity in what they was doing, to my estimation, to be men of intelligence. They said the attorney, the State's Attorney, Peyton Berbling, was the head of it. —AW

So theirs was to put the city under curfew. Not necessarily for everybody; just for blacks. —DB

I was very young then, and I felt that I was the rightest person in the world, that I was there for a reason. I was proud of that reason to be there. I'm making a difference; I'm hurting these people for hurting us. Oh, there was a little bit of fear there—somebody might shoot into the crowd or hit you upside of the head or something, or you could get arrested and go to jail, or be provoked into something and get a criminal charge. But you kind of put that to the side. The priority was to be there, be in force and have your signs ready, walk the walk, walk the sidewalks—protest. —CM

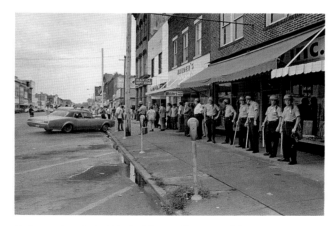

Police await arrival of black picketers. Commercial Street.
September 1970.

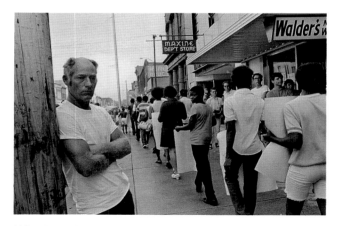

White bystanders and black picketers. Downtown. May 1969.

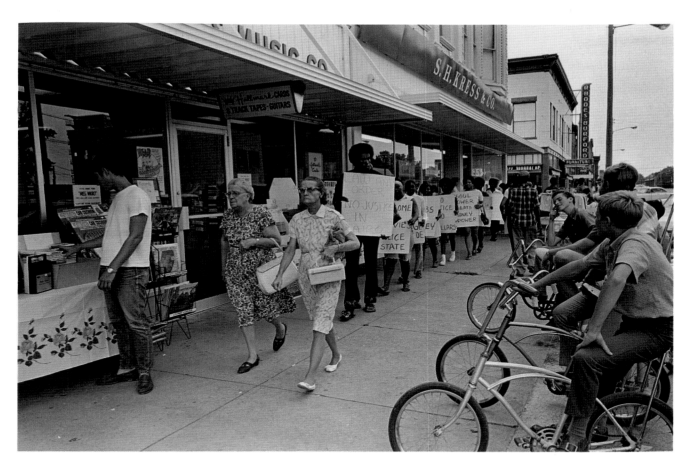

White youth gather at picket site. Downtown. August 1969.

We were getting on the white folks' nerves—as you seen in those pictures that Preston has. They could not take the pressure. And the only thing that we had to do was march, walk, and sing. And hey! They wanted to kill us! That was it. That's the violence. That's our whipping there. We didn't need to do nothing but march, sing, and holler, "Hey, we not letting nobody turn us around." We sing that song, boy, them people would get so mad! Ready to throw things, cameras, and everything at us. I'm like, "Don't worry me." —FS

White residents observe protest march from inside auto repair garage. Downtown. December 1969.

Have you ever been in a community where for one goal all age brackets came together—for one idea? From the oldest citizen to the youngest was on one accord. That is a sight and a feeling you get from nowhere else. . . . To energize themselves and to release all this feeling, in a constructive manner to where they could have a positive direction to go with it, instead of self-destruct or just hurting somebody. And that, I think, really got the establishment shook up. —DB

White residents watch protest march from parked cars. Downtown. Date unknown.

White residents gather to support boycotted stores. Downtown. June 1970.

■ *There were lots of instances—then especially—when you had to go around to the back door of a restaurant just to order some barbecue scraps or something. And people, they liable to spit in your food or something. —CD*

Just like Mac's barbecue stand up there. We had a bunch of peoples go up there and try to sit at the *counter, and they shot water on them. They had a big old hose. —CD*

I was riding a cab one night. And I decided that I wasn't going to go to the restaurant window no more! When I make up my mind about something, that's it. I walked inside and sat down. It was one white man sitting there. *[The waitress] said, "What do you want?" I said, "I come in here to be served." I said, "I'm not going to the window. My money is just like the other people's money. When it gets into the cash register, you don't know my dollar from anybody else's dollar. I'm going to sit right here and I want two hamburgers—two cheeseburgers—to go, and I'm sit-* *ting right here—and get them." That man said, "I don't blame you, lady!" I sit right there and I watched her. And she fixed that hamburger, brought it to me. I paid for it. I said, "Thank you." I paid the cab to wait. He said, "Lady, you going to get in trouble." I said, "Don't worry about that." I tell you, I felt good. I went back and got in that cab,*

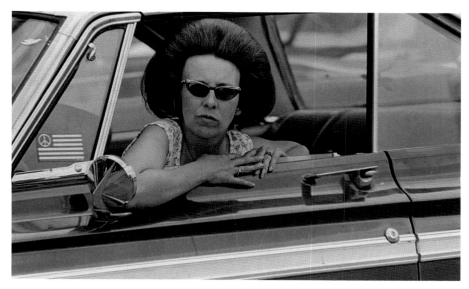

One of many residents who added to the white presence at black protest sites. Downtown.
Date unknown.

honey, and went on home and sit down and told my husband what I'd done. By myself. —HM

Here's what I don't understand. We trust people to take care of our kids, to feed them, laundry them. And then, we don't want to sit down with them? It seems odd to me. —AW

■ I used to have a friend worked at the fire department, his name was Douglas. He used to tell me the problems he had. That when he got ready to put his boots on, there'd be shit in them. Or they'd take rubbing alcohol and pour in there, and you'd put them on and work in them, and alcohol get in your feet and burn real bad. Notes would be on his locker. The ones they was forced to give them jobs—forced by court orders— were harassed for breaking the ice, for accepting the position. This was in the '70s, or something like that. I think he ended up suing them and got a settlement, and he just left. Probably figured—get up a ladder or something . . . —CM

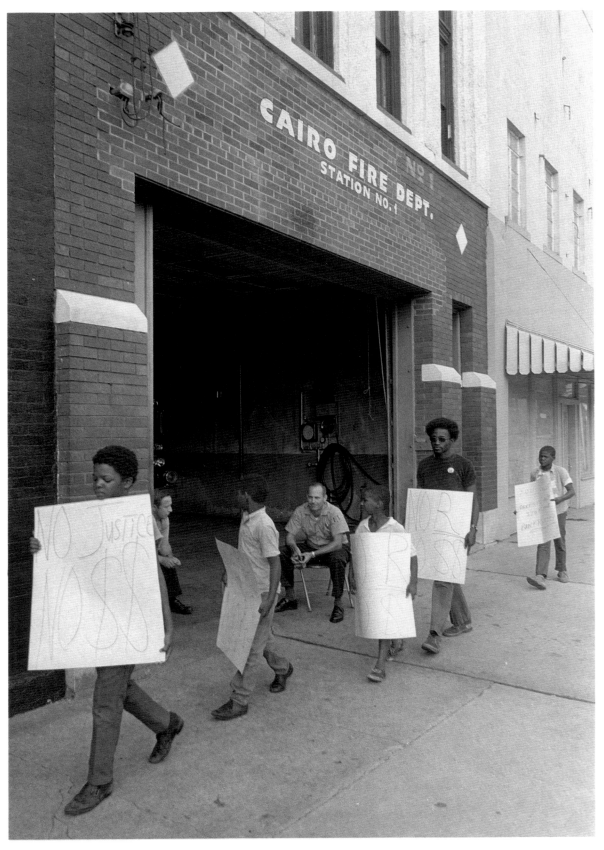

Picketers protest exclusionary hiring practices of fire department. Washington Avenue. May 1969.

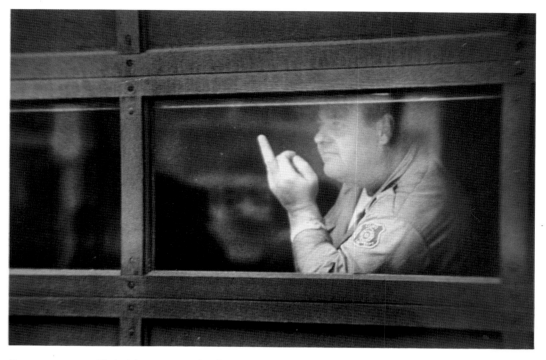

Fireman gestures at black picketers passing by. Cairo Fire Department. November 1968.

Ford company came in with the idea of setting up business here. The railway, highway, and riverfront—everything fit the proposal. So they said, "We can sit here and make a mint." And when they brought in the salary—how much they going to be paying—they told him to pack his stuff and keep on stepping! Because they had their little system on how they work things, and how they going to charge, and how they pay. They didn't want nobody coming in, elevating nothing. —DB

At the end of World War II . . . young men were told, "Don't go back home and take the same thing that you did before." And the young men went to the powers that be, and here's what they would say: "The time is not right. . . ." So the young men just left. When the young men left, you know, young women are going to start leaving, too. We went to a meeting in Peoria. They wanted to bring a part of Caterpillar down here—you know, a branch of it? I said, "Well, why don't ya'll tell the city fathers that you're going to do it?" They say, "No, the time ain't right." —AW

They had a boat factory that come in here. They had a chicken factory and a cab that come in here. And then they mostly hired people from Missouri and Ken- tucky instead of hiring local people. They've done a lot of things here that cut off their nose to spite their face. —AW

When Burkhart [Factory] came here, some of these people who had cooks and laundry women, the white women, went to them to say if they did take [black women workers], give them a different wage, a lower wage. —AW

See, I was raised up on welfare— [my mother would] have a account. So what kept downtown in Cairo flourishing was public aid recipients or some type of relief fund, because of their unwillingness to bring industry into this area. It was like a revenue bank for them, because they had constant income, little bit at a time; but if you get four thousand people with a little bit of income, you got a nice income in a month. And it's continuous, you know. —DB

That's the reason that Cairo died, man: because they didn't want no factories coming in, because they didn't want to lose their stronghold. You have five or six millionaires in Cairo, which control the economics of Alexander County. And they didn't want to lose their grip over the city, you understand? They the one that killed Cairo. —CD

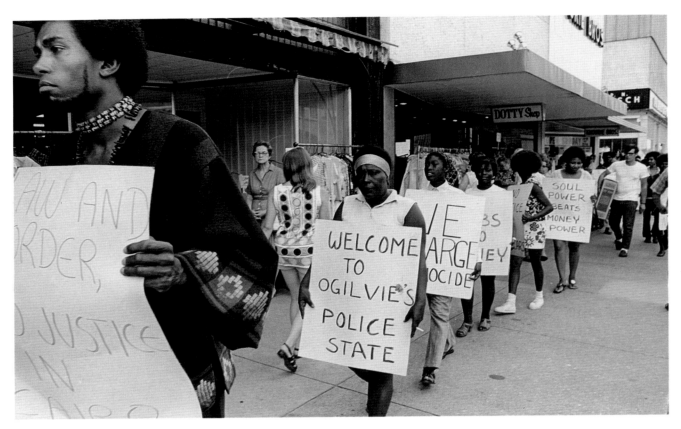

Picketers in front of downtown stores. June 1970. *Center*: Hazel Hardy. Governor Ogilvie sent the state police on a number of occasions to support local law enforcement efforts.

■ *[Whites were yelling] "niggers" and all kinds of things! Anything that come in their mouth that they want to make us mad about, but we march on. We weren't even reacting, till they hit one of us. —FS*

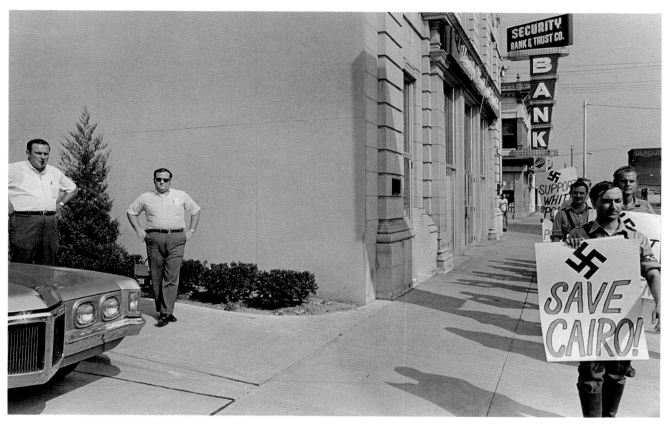

American Nazi Party members from Chicago march in support of local white residents. Commercial and 8th Streets. August 1970.

Nazi Party, they brought them in down there. But you know, I'd march awhile and I'd get out the line, because I'd say, "No, I'm not going to be nonviolent today!" One day it was some white girls over there. They was cursing so and going on. I got out the line and I walked to the sidewalk and I said, "I ain't going to be nonviolent today." Teenagers, you know? They was big enough to know right from wrong. I said, "You say it again, I'm going to give you this!" [gestures with fist]. And she went [opens mouth]. She didn't say it, either. It was really something. —HM

Oh, we had some nice white people that was around back then, man. We're not saying that all white folks bad. We had white people that was supporting us, for a change. They tried to play poor whites—didn't have nothing— and poor blacks—didn't have nothing. So, as long as you keep them fighting amongst themselves, and you throw them a crumb here and a crumb there, you always going to keep a whole lot of friction going on, you know? —CD

If you were white, and came here with an idea that was called growth and prosperity for all people—well, you gone; you didn't stay here. —DB

There was one publisher came in here and he had black proofreaders. He was just printing things as they were—and they broke the windows out of his newspaper. So, he sold the newspaper and left. —AW

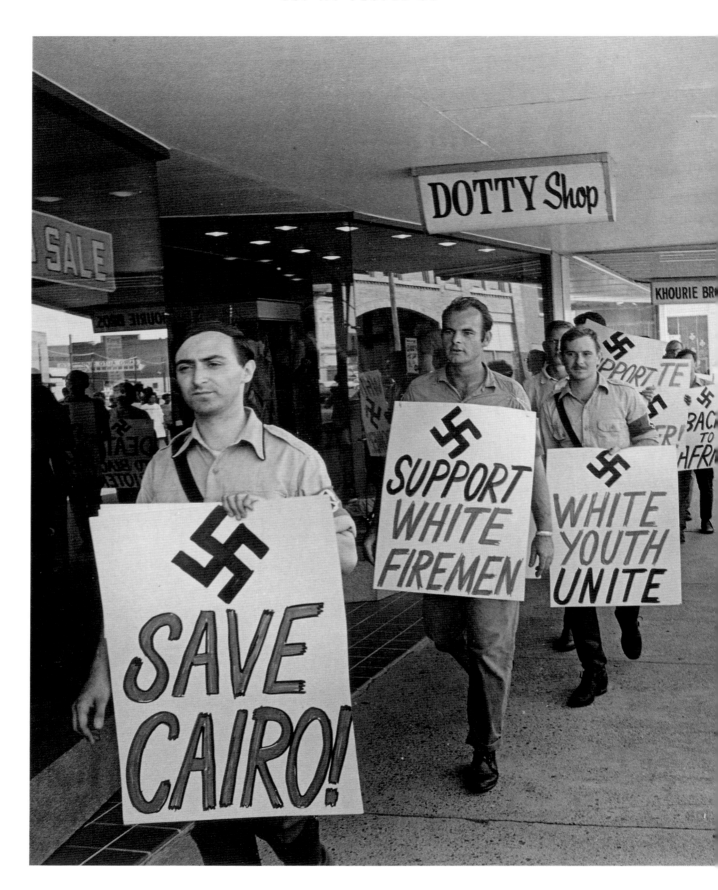

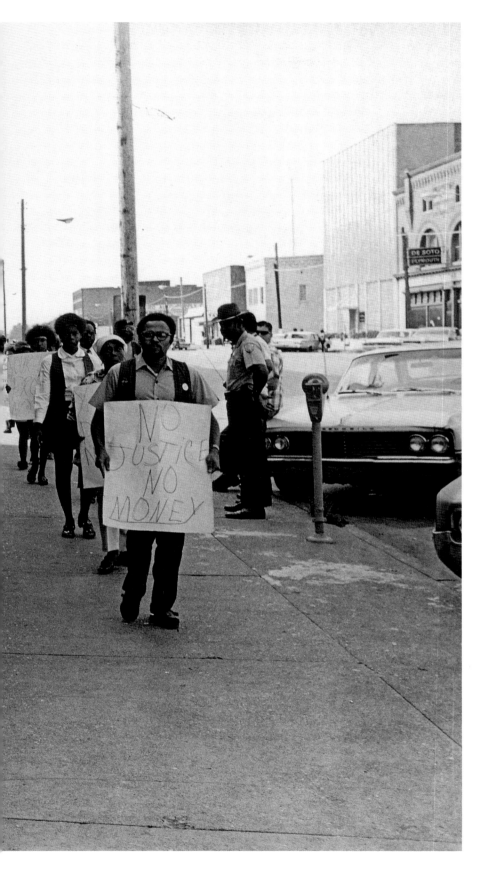

White doctors establish a clinic here. They were White Hats came in there and said, "All right, we came in to get some treatment." And they said, "Hey, we not going to wait in back of these niggers; we want service now." So Jane [the doctor] said, "Whoa, whoa! You just messed up right here. First come, first serve." "We don't do things that way here." She said, "Well, I'm not from here." They say, "Well, you won't be here long, either." And so they started harassing her. "For your own health, I think it's time you move on up out of here. . . ." They got up [and left town]. They had to get up . . . "because we got too many ways to hurt you." —DB

I remember some white Freedom Riders was here. I don't know where they come from, a college or somewhere, and they was at the courthouse down there, with Reverend Koen, Reverend Ramsey, and Preston, and some other people. And I remember a sheriff deputy came out the back door and hit one of them over the head—concussion, busted his eye and everything. And I remember seeing the blood coming down, and I thought, boy, that is something. This big fat guy came out of there, said something about being with niggers or something, and just hauled off and hit this white dude. —CM

We had a meeting in the back [of the Chamber of Commerce], and there was a big old picture of a Bo-Jangle's-type black and two bales of cotton! You know, a little Southern fallacy. —CM

Black picketers and American Nazi Party members hold simultaneous marches. Commercial Street. August 1970.

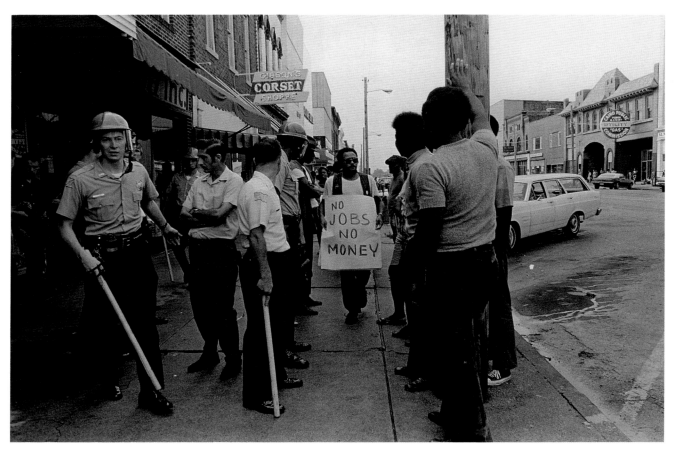

Black residents, white residents, and police officers gather around picketers. Commercial Street. September 1970.

■ *I can remember the mayor—*
past mayor, I served with him my
first term, Al Moss—getting into
[it] with some black downtown,
and licks was passed and pictures
was taken. —CM

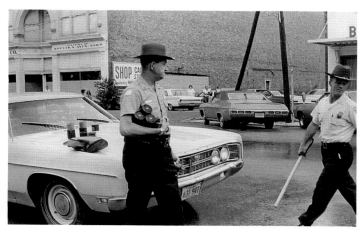

Police Sergeant William Pitcher (holding tear gas canisters) and Chief Roy Burke prepare to confront black picketers. Downtown. June 1970.

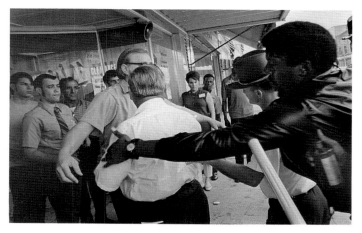

Mayor Pete Thomas (with back to camera) confronts boycott supporter Rev. Manker Harris. Downtown. July 1970.

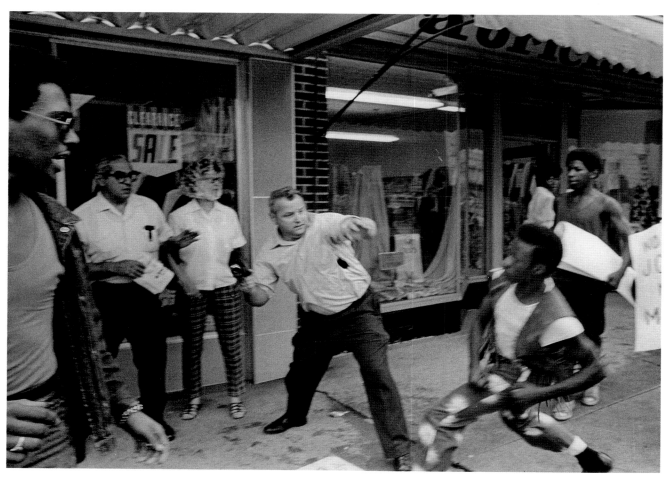

City Councilman Allen Moss and picketer Ernest Morgan in a confrontation. Commercial Street. July 1971.

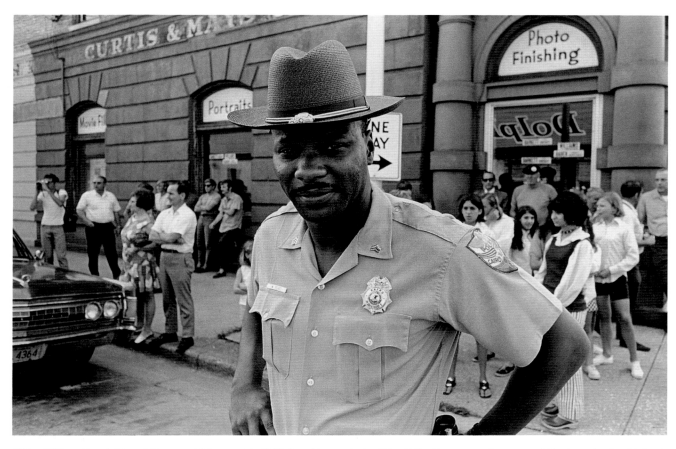

Officer Wilbert Beard. 8th and Commercial Streets. July 1969. Beard later quit the Cairo Police Department in protest of illegal acts by the chief and other officers against black citizens.

You might have had one or two blacks [on the police force], but they never were put out there when the white department would do something. They either had them off duty, or put them at a desk. You know what I'm saying? —DB

And they had them big sticks and they was saying, "Get back." I was there with my baby. And my husband said, "You better not hit my wife!" They hit—and he was so mad. They was all up on top of the buildings with they guns and stuff. They hit my car and *put a dent in it. Sure did. They were hateful. They were hateful. —HM*

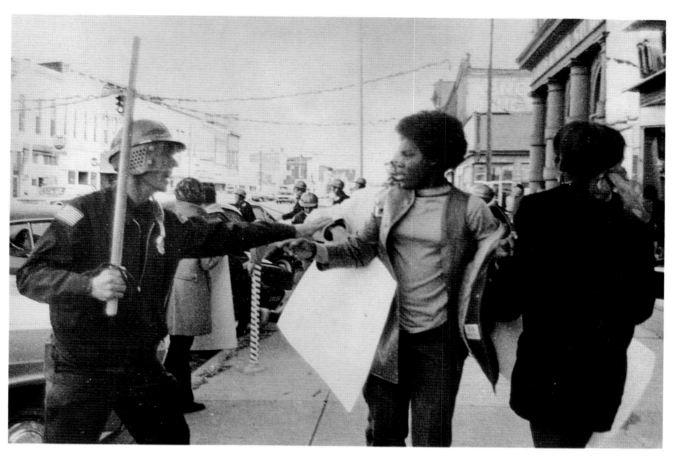

Police officer confronts picketer Cassandra Whitfield. Commercial Street. December 1969.

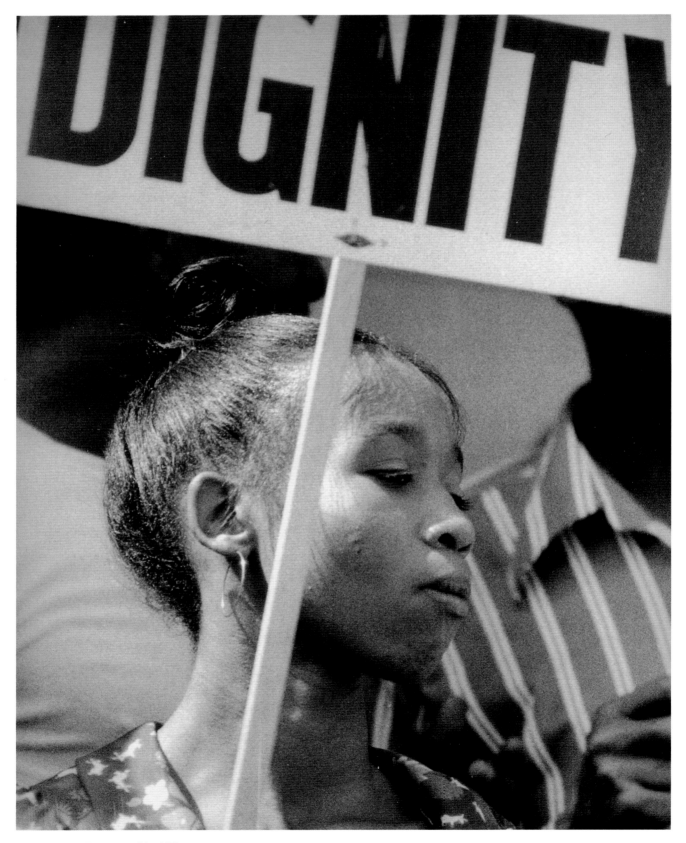

Young marcher. Downtown. May 1972.

White supporters of civil rights outside police station. Washington Avenue. May 1970.

Justice, especially in this community, was being able to go to court, and being charged with a crime, and if I was innocent, I would be proven innocent instead of being proven guilty just because I was black. Justice to me then was being able to go in any restaurant, in the front, not in the back, and sit down and eat. Being able to go and put an application in and being interviewed on that application, rather than have it thrown in the trash can. Of being able to sit down in someone's home and being felt welcome or being able to socialize and talk. Being able to go to any church that I felt I wanted to go to, any bar that I wanted to go sit down. As far as economic, civic, social, religious, whatever—it's just so that everybody had a fair play and a fair shot at life in Cairo. I wanted to see that for everybody. —CM

■ When I was real small, like six or seven years old, I would go to Washington Grade School, which was the black school. And I would pass by a white policeman stopping traffic so we could go by, and at that time you never thought that you could become a person like that. You thought that wasn't for you—you just was never going to be able to be a policeman, a fireman, work for the Cairo public utilities.

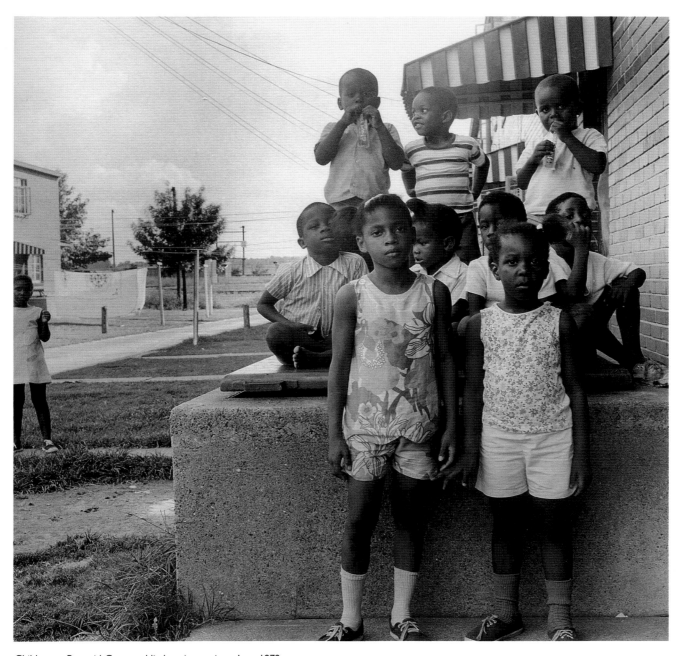

Children at Pyramid Court public housing project. June 1972.

*Not ever seeing blacks with those
jobs, you figure that "I don't have
a chance"—it just didn't happen.
It was beyond approach. —CM*

Poster in a storefront advertises a local radio station's annual beauty pageant. June 1970.

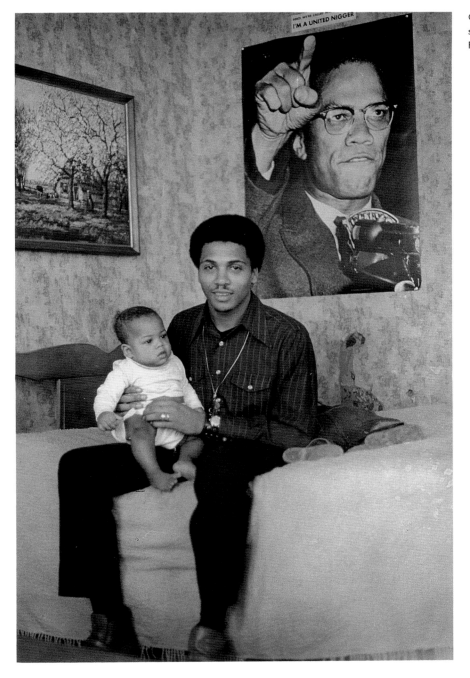

Cordell McGoy and his son Marcus in their home. February 1970.

The teachers was afraid to show concern for minority students, black students particularly. Because the board was predominantly white. And the school faculty was predominantly white. The principals was all white. So, at that time they had to do what they was instructed to do. "Those people are there and you got to put up with them. But first you must show all your concern for the white students. You got to put up with the black, because the court says they are here and nothing we can do about it." Even in their programs, Christmas programs and different things like that, you could see the racism there. "I'm afraid to really let you come in and have this part. I'm going to let John have it because John lives out on Holbrook, and his daddy is an attorney in town, and he's white." —CM

I had a white friend named Mike Carr, and he's a friend today. He came around and wanted to dance with the black

■ During the time they integrated the school, they had started a little small school, Camelot, to keep their kids from going to mixed schools. White folks had taken their kids out of school and started a private school. —CD

There was a lot of energy, a lot of finance, a lot of everything was centered around Camelot, because that's where your upper-class students were—came from upper-class families. Because those people that you had in the public school system was blacks and poor whites that couldn't afford to go to Camelot. —CM

[Before school integration] they had ordered new books. But what happened is they sent us the old books from Cairo High School over to Sumner High. So I asked our principal about it. He said, "Well, uh, that's the way we do thing." I said, "Oh, man." I said, "Wait a minute." Then I said to myself, "Now, he done went to college and everywhere, and he's telling me that they got to put up with this." —DB

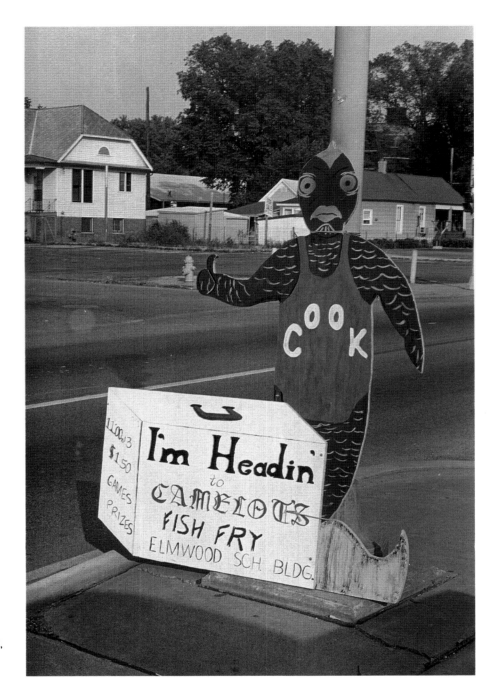

Caricature of a black cook on a sign for the white private school, Camelot. Washington Avenue. August 1970.

girls and wanted to talk to me at the prom. He told me the next day that they put a gallon of paint on his mother's car that he took to prom. His mother got a phone call, and they said that "if he doesn't stay away from those niggers, we'll burn the car next time." —CM

They integrate the school, right? So this gym across from the old Sumner High School was sitting beautifully. It had a beautiful floor—perfect. And so we wanted to purchase it, use it as a gym for city leaguers—you know, people out of school, young adults. Perfect gym, auditorium, stage, and everything. We wanted to use that building, because as our

alma mater, you know, our heritage here at Sumner High School Building. You know what they did after they saw that we could do it? They went over there and drilled holes all the way through the damn floor—drilled holes. They was going to "set it up for stage props," but they never put anything in the holes. Now it's not usable because "by mis-

take, we were working on it and we just accidentally put one thousand holes in the floor." Then they wonder why we get mad—"Whatever projected him to just get vicious and go off like that?" Man, if you get stuck with pins enough, you going to holler for something, you know? —DB

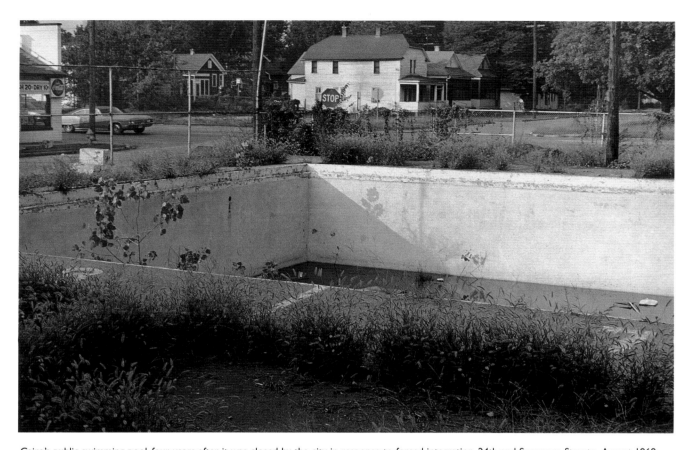

Cairo's public swimming pool, four years after it was closed by the city in response to forced integration. 24th and Sycamore Streets. August 1968.

■ *We had a swimming pool, and when they decided to integrate the swimming pool, man, they closed it down—they poured concrete in it. It's up there, right behind the car wash now.* —CD

I didn't go in there to do nothing to them. We all showered before we went in, so there was no *hygiene problem, no problem that I could see at all, rather than just that I was black. I went in there to do the very same thing [the white kids] were going to do; swim on a hot summer day and go home. It was a very confusing and heavy trip. Worked on an individual's mind—even today— because what happened to you* *when you grow up, sticks to you, hurts, and still bothers you today.* —CM

After the pool closed, kids started running the streets, kids started swimming in the rivers and the creeks. And we started losing kids every year. We still do. —CM

They stopped selling the [Newsweek] *magazine. They took it off the shelf here, because they was interviewing the white people, and they said, well, "White people swim in the pool, and the colored people drown in the river." They put that in the magazine, and they stopped selling [it here].* —AW

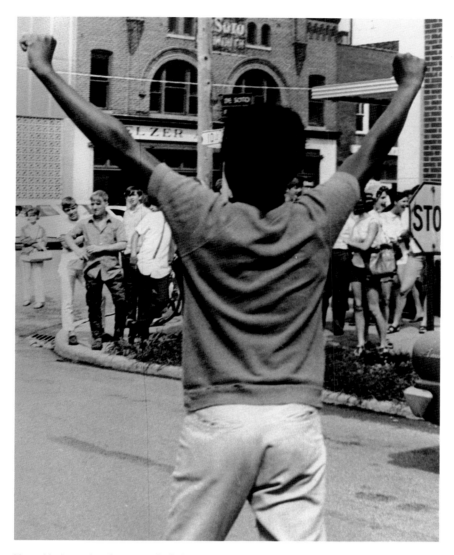

Young black marcher faces crowd of white onlookers. Downtown. Date unknown.

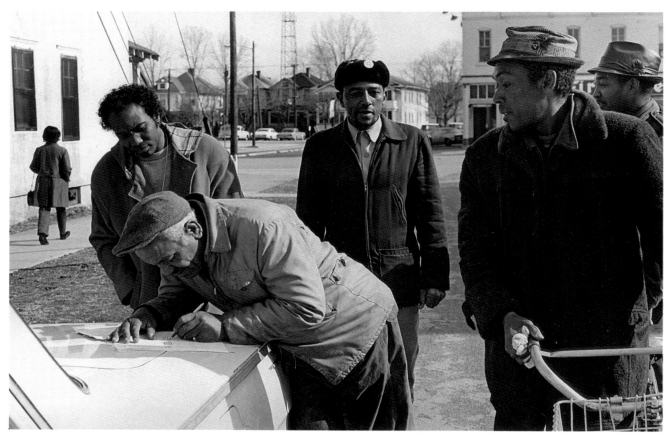

Black citizens add their signatures to civil rights petition drive. 14th Street. November 1970.

■ *They was organized. . . . Like when peoples come to our Saturday rallies, peoples from all over the country that came in, they would set up clothes drives and send clothes down here in big U-hauls and things, food drives, because we refused to shop at the stores downtown, and food and clothing came in from all over the country. —CD*

I remember we had a—called it a Black Thanksgiving. [The United Front] said they didn't want nobody hungry. Want everybody to have a dinner. They brought in—they paid over a thousand dollars for turkeys and food and stuff. I remember ice was on the ground, and when they brought it, I went out that night to deliver turkey and cranberry sauce to the families. Every house that could cook and

wanted a turkey, they got it with the trimmings. They paid some women to come in down there at 12th Street and cook for those who wasn't able to. Everybody had a Thanksgiving. —HM

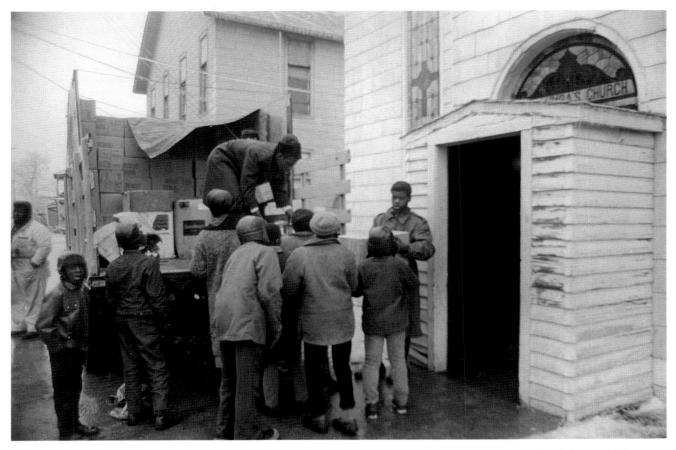

Youths unload shipment of food donated by out-of-town group of Vietnam veterans in support of boycott. St. Columba Church. January 1971.

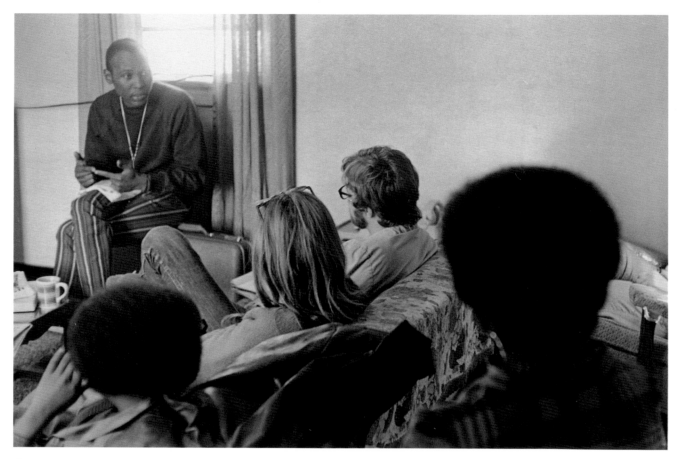

Out-of-town college students are briefed in a local home before beginning protest activities. Date unknown.

■ *It's nothing like it is now, you know. White peoples—they had a justice system. And the black peoples—they had a justice system. That's the way it was. —CD*

They said that in all those years, that no black person ever got to serve on a jury. All white jurors, if they had a jury trial. If they didn't have a jury trial, they send them on to jail anyway. —AW

In a year they arrested three hundred blacks; I think they sent three of them to prison, and they didn't arrest any white people at all. —AW

If the blacks and whites got into it, a lot of the blacks went to jail and I think the whites went out the side door. It was a sad situation. —HM

A lot of times back then, they would take you to jail, man, and beat your ass with a rubber hose. They would railroad your butt on to jail. —CD

We went up to Springfield to Governor Ogilvie's office and a lot of us was arrested because we refused to move. And the only thing we was doing was singing, "We're not gonna let nobody turn us around." Throwed us straight

in jail. They were waiting on us. They already knew we was coming. We went to the capital for help, but we were also trying to get publicity. So that people nationwide could see what we were doing and that we wasn't wrong in what we were doing. They put us in jail, and we stayed there for, oh god, had to be about three weeks. When I come back home, my baby didn't even know me. —FS

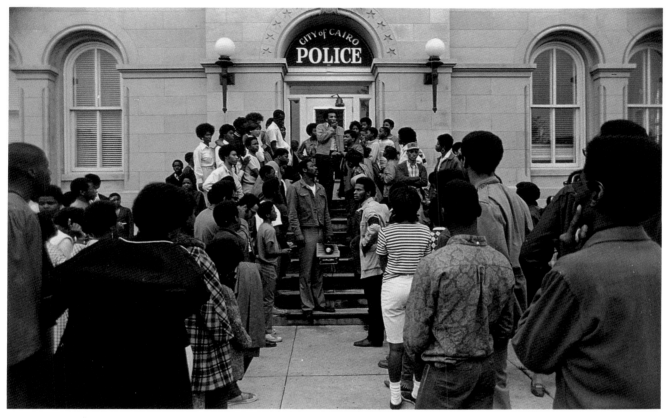

Crowd at police station protests the illegal arrest of picketers. Washington Avenue. March 1970.

Our attorneys go to city hall to file complaints, and by this time the merchants was furious. I think one of them threw a rock, or they slapped—hit somebody— and eruption started on the court-house steps. And the state troopers came out in defense of the pro-testers, the picketers, because we were going in to raise a com-plaint. This time the merchants, they had lost all sense of control. They pulled the flag down, stomped it, and set it on fire, right there. They were smashing cameras, because they didn't want this type of reality to surface. What they were saying was that the government turned on them: "We are the true Americans, they are not Americans." "This ain't justice." But now, to go and regis-ter a complaint against an unconstitutional aggression—it's American. —DB

Movement supporter Father Gerald Montroy. St. Columba Church rectory. May 1970.

Every day, individuals could come and talk to the committee, cause the lawyers' areas was there for the defense of the Front and its participants. So if you run across a problem that you felt was discriminatory in nature, you go down and file a grievance and fill out a complaint and they will answer the complaint. They were there for the public. —DB

Lawyers with the Land of Lincoln Legal Assistance Foundation, representing the Cairo black community in a federal civil rights suit to end discrimination in the local court system, outside the U.S. Supreme Court building. Washington, D.C. October 1973. *Left to right*: Robert Schleshinger, Marge Stapleton, Michael Seng, Carol Pauli, Larry Ruemmler.

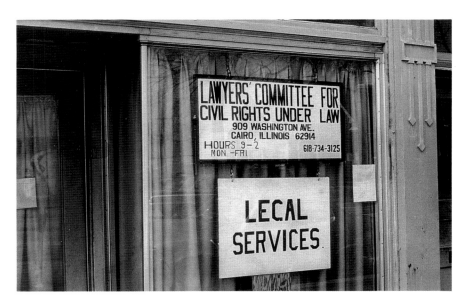

Branch office of a federally funded legal services group established during the movement. Washington Avenue. Date unknown. The Land of Lincoln Legal Assistance Foundation and the Illinois Defender Project also operated storefront offices in Cairo.

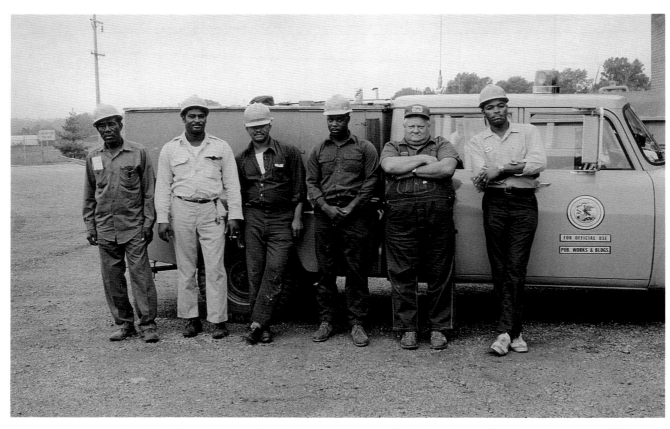

Highway maintenance workers, hired after employment discrimination complaints were filed against the state. Washington Avenue. April 1970. *Left to right*: Jessie Sowers, George Ramsey, Joe Nelson, Abraham Houston, Vaughn Palmer, Bobby Whitaker.

■ *Blacks started being elected to positions of school board, and city councils, and being involved like I got involved. See, I forced my way into things. . . . You might not want me there. But I'll force my way in and I'll work real hard and you have to accept me! So I make you accept me whether you like me or not, because I do things that need to be done; and they say it's hard to turn your back on progress. —CM*

They had an agreement made between here and the region's [post] office in Carbondale that when you come across and see a black applicant, no matter what your score was you didn't pass the test. So happened, I knew some people who was in the department; we were pretty close. So this individual say, "I just saw your exam; came across the other day. I'm going to make sure it gets to the register. So if you don't hear from them in ten days, that means somebody was sacking up

the register." Once it gets to the register, they won't dare touch it; they let it ride, but then they work from within the system to get you out. After I'd been there for thirty days, they had fabricated stuff already to get rid of me. —DB

You can constantly see things, man. See, I've been in the union seventeen years and you see somebody in there that ain't got no card out there working more hours and more things than you

have. Then you just go out and get you a beer or something to try to release some of that sting. —CD

Don't just give me a fish, give me a fishing pole so that I can catch my own fish, you know? Like, we're not asking for no handouts. We want to be independent, upon our own, and do things for ourselves, you understand. —CD

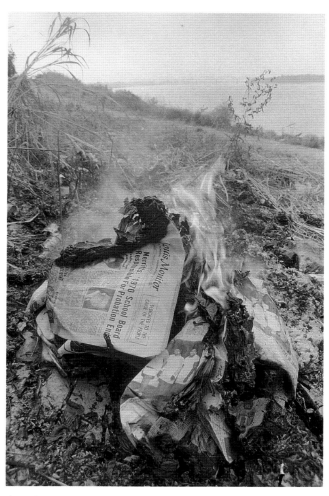

One of 1,200 copies of the *East St. Louis Monitor* that were stolen and burned before they could be distributed. Ohio River levee. June 17, 1971. The *Monitor* was the only official news source that covered the local black community and civil rights activities.

■ *They wouldn't give us access to the radio or newspaper. They wouldn't even take a paid ad. They would say, "Well, come back tomorrow," and you go back and they tell you to come back later. By then, the paper would be out. So you couldn't advertise through the local radio, television. The only time they would come in is when something burnt up or somebody got shot. —CM*

One of my friends call me and said, "Hey, Anne, what's going on?" I said, "Nothing." She said, "Look out your window." I looked out my window—and [a nearby building] was just in flames! I guess these people must have been going in the 'hole,' right at 15th and Walnut—it was a wholesale place. It was on fire and got the houses on the other side on fire—15th Street. Looked like they weren't ever going to get the fire out. I said, "God has forsaken Cairo." And He sent a rain to put the fire out. I thought it was going to be all kind of people at church the next Sunday, because it was Saturday night. Still got the same few crew in there. I was disappointed. —AW

I would say most of the business people saw that, rather than give their power up—or give employment to blacks—they'd burn their business and leave town; saw one day there was going to be a change and they didn't want to stay here and see it. —CM

I think the TB sanitarium—that was city property—that was one of the first things that went. Other than that: the VFW post—we didn't burn that down, blacks didn't burn it down. I don't believe blacks did the clinic either, but it's right in our neighborhood! "Hey, look what you all done!" A lot of things in this town, where they would cast the blame out of order. But it's strange how obvious places that should have burnt never were touched—if blacks were going to do it. —DB

Well, there was a store burned over here, called the Johnson Market. Fire people, they tell me, burned this store right here. He was pretty nice too, Johnny Johnson was. He was pretty nice to the people. The white people didn't want him to sell groceries on credit to black people, so—I don't know. Anyway, he left and went to Florida. I can't remember exactly whereabouts the Palace was, but it was beautiful; had nice clothes, and blacks owned it. I was proud of that store. But one night, a bunch of those guys— they said they was firemen; I knew they was whites—burnt it out. They sure did. They set it afire and ruined it. I remember that. —HM

They also burnt out Preston's brother's record shop. He had a beautiful store, and they burnt him out. It was a lot of burning and bombing down here during that time. It's a lot of burning. —HM

He wouldn't say a thing. I said, "Are you a policeman?" and I kept asking him; and I knew something was going to happen, because up at 28th and Poplar— it's a tavern there—usually these White Hats and things hung around. I say, "Well, I think I better get on home, because something going to happen." In the meanwhile, there was a Family Center owned over here. And when I called home, my son told me, "Mama, stay where you are. It's burning up down here." —AW

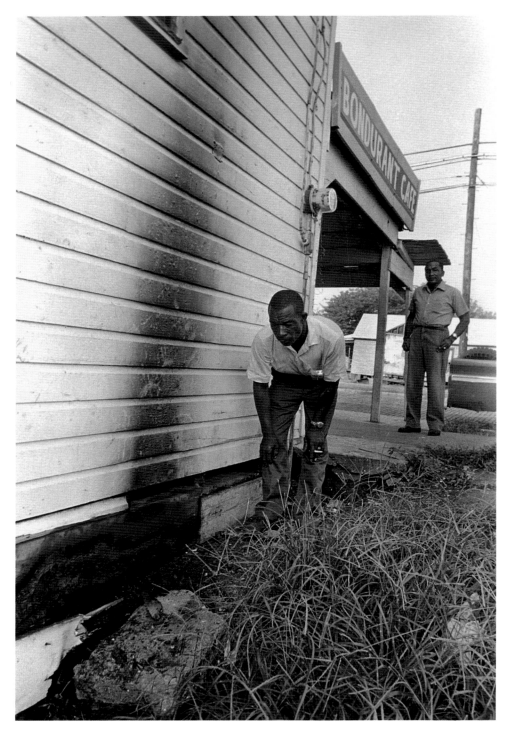

Firebomb damage to a black-owned cafe. Poplar and 23rd Streets. August 1968. *Left,* Ned McCall; *right,* Vance Futrell.

getting long." So they let her through to talk to them. —AW

I came back home, and at north Cairo the conductor didn't want me to get off the train. I said, "I'm at home, so I got to get off the train here." He put the step down. And I called for a cab. No cabs were running. And they say, "Nobody can go in Cairo. Cairo's under curfew." I say, "I be there." I thought about it the next morn-

One thing I found within that whole episode was that when a group has the upper hand and time is on their side and all the equipment, they tend not to get upset, because they have a strategy. But when that strategy is threatened, they become more

vicious than the maddest dog on the street, and that's what happened in this case. —DB

They close the telephones down. They used the operators; wouldn't let a call go through to Pyramid Court from a certain time at

night till the next morning. When I was on vacation, my sister called out here one day and she said, "They said they couldn't put a call through to Pyramid Court." She said, "My sister's out of town and her children are there. I need to know how they're

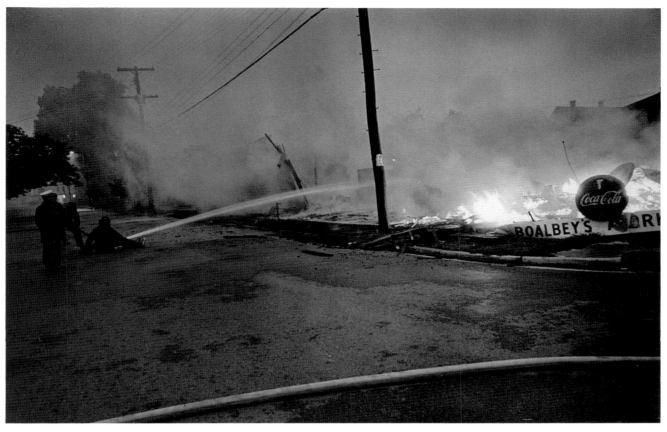

Fire at a white-owned market, one of many suspected arsons. Near Pyramid Court. Date unknown.

ing, after I got home. I should of called and told them, "A black man is killed a white man out here!" —AW

They had little codes that came over the radio, and you could tell when they was planning to do something that night. Then the man I worked for, he would come home and tell me when things were happening, but I would have already known! Because I

kept the radio on. I don't know anything about music, but I would know these themes, and sometime I called a radio station. I would make out like I was white and he would tell me a whole lot. —AW

It did blow up. It got so bad, man, it was like an armed fortress. You had peoples that was coming in and, you know, it was very explosive around here. —DB

I was always relaxed, because there was no use in everybody getting scared. But we used to put blankets over to the window when we were going to read something at night—so that they couldn't see a light. —AW

There had been complaints of people being shot at, cursed, threatened, and stuff like that— about being in a certain area after certain times at night. Plus,

we had a lot of curfews, too, imposed even by the governor and the state of Illinois. And National Guard was here—a lot of problems. —CM

At nighttime—they never did front openly, because it was unlawful organization and they couldn't retaliate on a peaceful march. But their thing was to do sniping at night. —DB

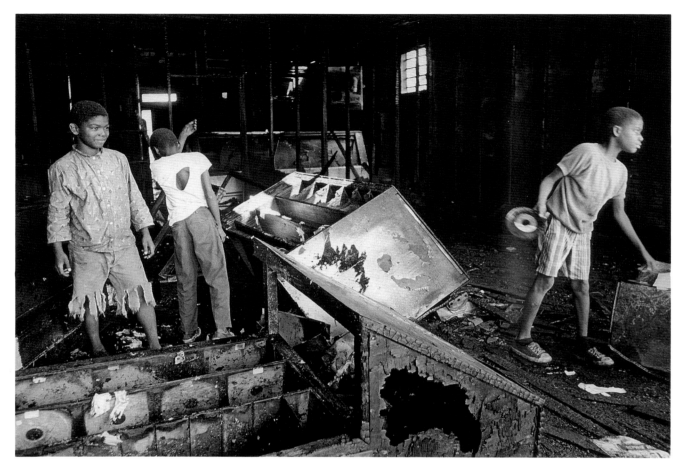

Boys rummage through remains of Music Unlimited, a black-owned record store, after a suspected arson. Cedar and 21st Streets. July 1968.
Left to right: Gabriel Ware, unidentified boy, George Ware.

The whole town was shooting back. We knew a lot of people that was protecting their rights. —FS

There was no real evidence brought out, no one was tried and convicted; all I know is that his house was shot into and he was killed. —CM

I can remember Reverend Koen saying, "Are you afraid?" I think

I was about twenty-some years old. I said, "I'm not afraid, but I'm concerned about those people that got killed in Chicago [when police shot into the home of Black Panther Party members]. I said, "Just like it happened there, it could anywhere. They could come in our home in Cairo and do the same thing." Then I can remember him saying, "Well, if you got killed, it would be for the most worthy cause a person could ever

*be killed for. I'm not afraid and I don't want you to be afraid."
That kind of touched me because I was afraid really, and I didn't want him to know it.* —CD

When they went out that night, Reverend Koen and the ministers was attacked by a bunch of whites that had been drinking a lot of beer, and they really roughed them up real bad. They didn't want them in the skating

rink. They said, "Niggers, we want you to leave now." "No, we want to come in and roller skate." And there was all type of hell broke loose. —CM

I went to the barbecue stand one night. You heard of Reverend Potts, haven't you? I was sitting on the car, my friend was going in to buy some barbecue. And they brought a motorboat [filled with guns]. And they went to

Deserted downtown under curfew during a period of night shootings. Commercial Street. September 1969.

Cairo Baptist Church and unloaded those guns in the education building. —AW

One night, we went to a meeting up at Cairo High, and they said, "They put out a bomb threat." We were meeting at the library. There was three of us and, well, they wanted to run. I said, "No, you just throw your shoulders back and walk. You don't have to." They say, "You want to die?"

There's me walking! But you don't run, you don't pick up and run. You just walk. —AW

At that time, we probably spent a lot of nights up because there was a lot of shooting from the vigilante groups, as well as the people defending themselves in the housing projects in Pyramid Courts. I lived on 11th Street, within walking distance of the housing projects. And at night, we'd mostly

either sit in the bathtub or we just stayed up listening to gunfire. You know, you don't get much sleep, and I had to work and had a young family at that time. —CM

You'd get up under something, on the floor, behind a table, in front of the couch—anywhere where you think a bullet coming through it's going to stop it. —FS

Just do what we had to do, and when night come, do what we had to do again. Like I say, wasn't no turning around. It wasn't no backing up, because you don't never start something if you can't finish it. So get busy. —FS

■ *Oh, the policemen used to ride around in them big, old tank cars, you know? It was— some of the police chiefs wasn't right. Some of them wasn't right.*
—*HM*

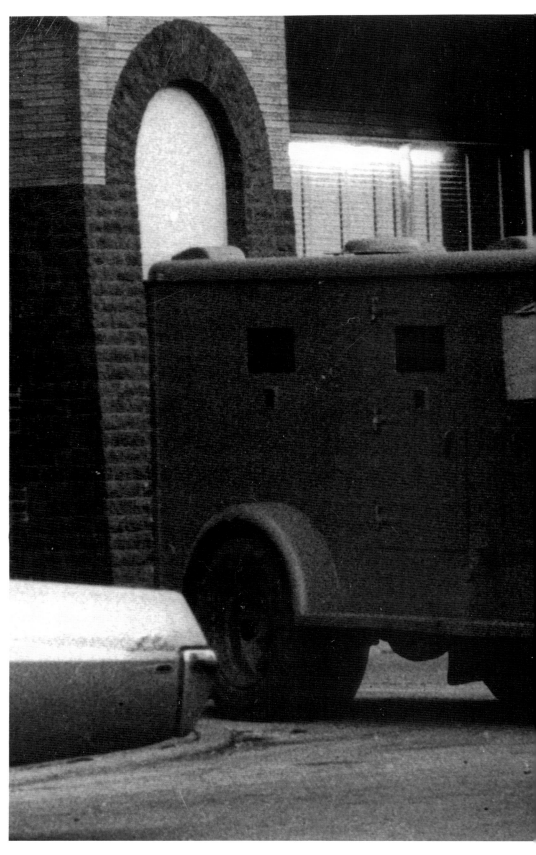

Police department armored vehicle and squad car on patrol. Commercial and 9th Streets. Date unknown.

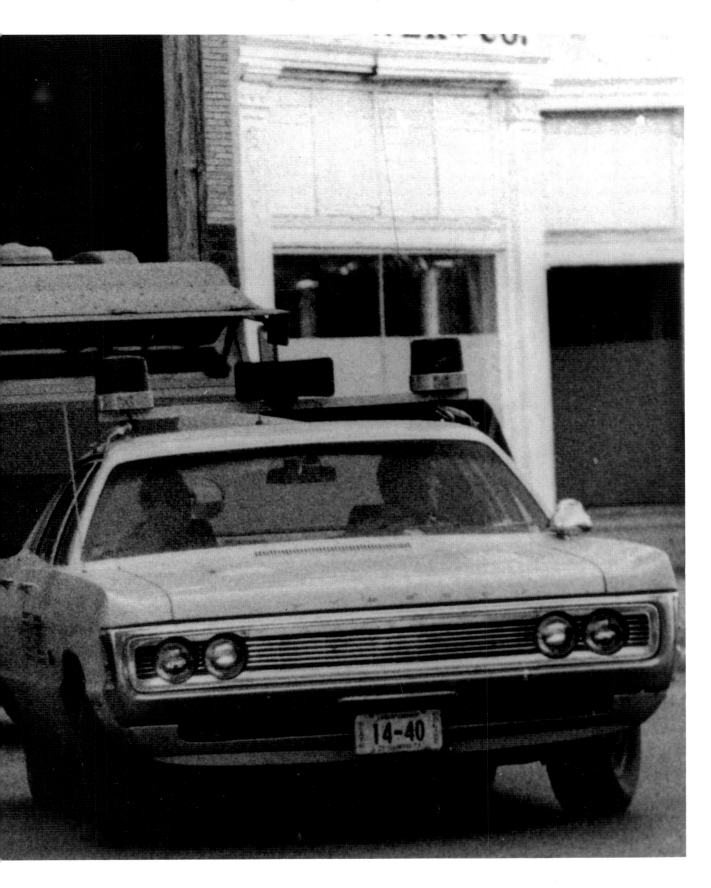

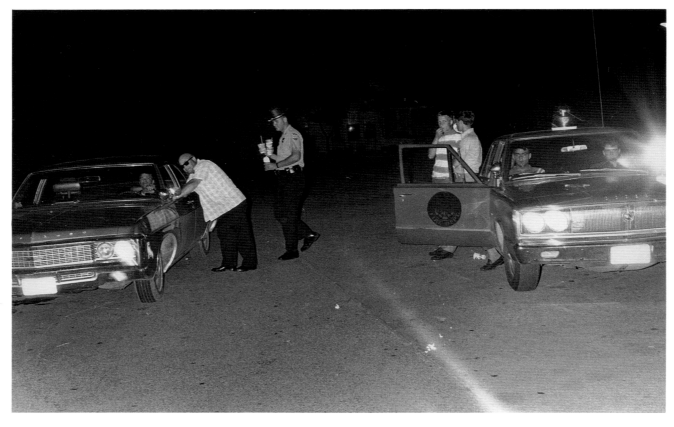

Police officers socialize with white residents during night duty. Downtown. Date unknown.

They said the state police, you know, were right in cahoots with White Hats. —AW

Well, the police headquarters used to be over at the old custom house, and they go up in that loft part of it and shoot out toward the project. They had those high-powered guns. —AW

They could shoot out into the projects and everywhere. It was all one big family event setting. It wasn't just law enforcement and White Hats. The restaurant right around the corner there, that was where [white] people used to hang out, across from the police station. —DB

■ Most of the time, I think, didn't nobody know what beds were during those times. We all slept on floors, because bullets don't have eyes and you never know, with all the gunfire coming in the project or going out the project. You never know when a bullet coming in that window, or wher-ever. Even lying on the floor, you were frightened to death. So it was, like I say, Vietnam. You didn't know where to turn or what to do. Nightfall—that was one time everybody's child and every-thing else was in the house! Yeah, better have everything you need before night come, because if you didn't, you'd be in trouble. —FS

You saw firing and houses tearing down, burning down. During the day it's quiet; you probably wouldn't hear a bird chirping too much. It was like a war zone; it was unreal. —DB

I never seen nothing like it. You know, all us that went through it, I'm sure they're sitting there won-dering, what happened? Why, you know? That white people just take control. They think you ain't nothing. They look to kill people and get away with it. It—it's devastating. —FS

St. Columba Church and Rectory, May 29th, 1971:

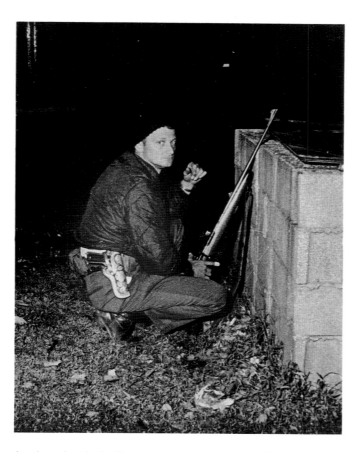

Local merchant Leslie Chrestman crouches behind trash bins near Pyramid Court, a black housing project. November 1969.

At about 10:08 P.M. we heard a shot fired. It sounded as though someone on the east side of Washington Street was firing in a westerly direction between 14th and 15th Streets. [The Custom House, which housed the police department, was the only building in that vicinity.]. . . . Father Montroy and I both hit the floor while Father Bodewes quickly turned off the television and lights. . . . There was more gunfire coming from the same direction. . . . Father Montroy ran first from the living room through the kitchen and the passageway that leads to the church—at that time a shot entered the house. Father Bodewes then channeled me through the same run and into a pew at the church. The three of us remained there alone and unarmed until the State Police came for us at apx. 12:15 A.M. Sunday morning. During the two hours we were in the church we heard gunfire—almost constantly from the same direction as the first shot. Father Bodewes' (in the pew next to mine) and my clothes were at one point covered with plaster bits—a shot having penetrated the east wall of the church and the debris falling down upon us. . . . Tear gas was shot into the building . . . and landed in the bell tower. . . . Father Montroy and I had both feared someone was breaking into the rectory trying to reach us. . . . More tear gas was shot into the rectory and church in the hours that followed. . . . Father Montroy placed a phone call from the rectory asking for the State Police to come for us in the armored truck. After a twenty minute wait during which the three of us were lying in the vestibule of the church in order to breathe . . . I went back to the rectory and called the Chief Counsel for the Lawyer's Committee whose staff I am on. . . . After placing that call the state vehicle came for us.

—From a written deposition by attorney Helen Belsheim

Interior wall of a home adjacent to Pyramid Court, showing bullet holes left by gunshots fired from outside. January 1970. The child is Marilyn Davis.

White people, one night, they was shooting over there. Wilbert Beard, he was a [black] policeman. Him, my husband, and a other young man crawled up on top the railroad so you couldn't see them. They caught this guy, a prominent white man in Cairo.

They caught him dead to the right, and they carried him in—and you know, they didn't do nothing to that man? Somebody could've been killed! They was shooting at us like we was rabbits! Just like target practice! —HM

Oh, it was terrible—I mean—because of ricochets and children; it's not fair to them. They don't understand, they can't rest at night. Most of them slept in bathtubs or under their beds, and that wasn't their normal, growing-up conditions. —CM

Bullet holes in a bus used for civil rights activities. Outside St. Columba Church rectory. May 1971. Actual casualties from gunshots were quite low during the period; the incessant shooting was apparently intended as psychological warfare.

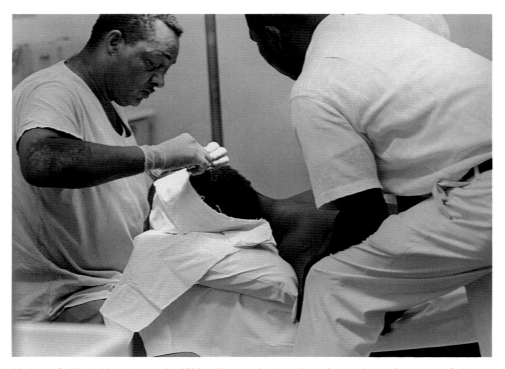

Medics at St. Mary's Hospital attend to Walter Haynes, a local resident who was beaten by a group of white men. Date unknown. Because of segregated facilities, blacks were frequently subjected to unreasonable delays in medical care.

■ *You always had trouble with doctors. Blacks had theirs, whites had theirs. Always, that was always. —CM*

We used to have to go to the annex. They train nurses out there, and they put us in a part of the old hospital. You had to go in the back door. —AW

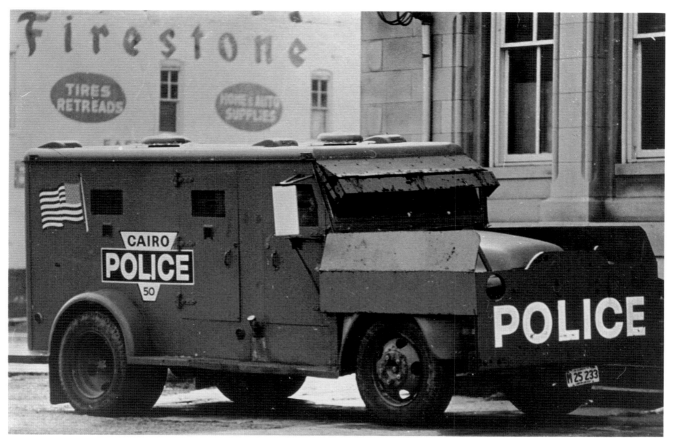

Armored vehicle used by Cairo police. Cairo police station. February 1970.

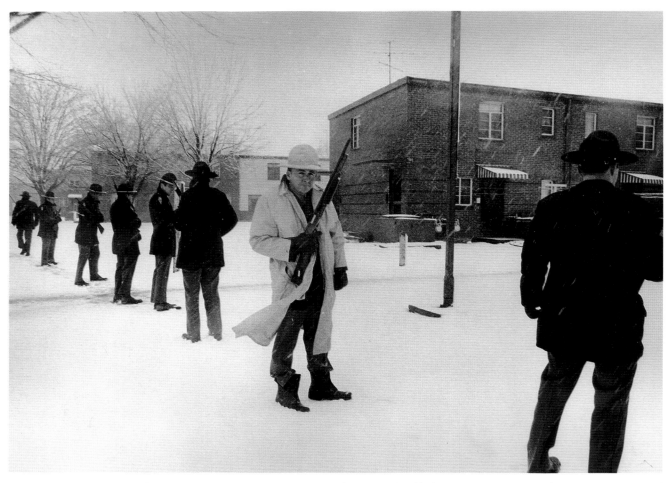

State police and national guard forces join local police to surround Pyramid Court, a black public housing complex, during a firearm search and raid. January 1971.

■*So their whole method was to have the National Guards, state troopers, and the city police come down to reinforce their decision of this curfew. We were made aware of this whole network, so our thing was to have every photographer from around the state on hand. First came the state troopers—I think it was about one hundred of them—lined up ten wide across the street. And then came the city police, and the National Guard had already set up a perimeter around the levee. So when they came out, everybody say, "No, ain't nobody going to jail, not for this." So then they started: "Everybody's under arrest." They set up a method to where the National Guards would guard the perimeter, state*

troopers and the city department would go in and confiscate our weapons. They still doing their bluff tactics: "All right, we want all the males to go in the house, females come out with the guns. We will take all the weapons." We were supposed to go for that—right! It was comical really, but it was real, all right. When they came to the project, it was almost like all age brackets came together, had the realization we've got to battle—something got to be right—for human rights.

By this time, [Police Chief] Peterson got on his bullhorn: "All right, we are going to make a house arrest, everyone. We taking all weapons today." All of a sudden, they heard windows break-

ing, guns, like cannons coming out of windows from everywhere, and all the younger brothers lined up on the front fence and cocked. It was down to the point where it could do just like [snaps fingers]. Anybody could fall and drop a gun, and it go off, and gunfire was going to erupt. Because it was to the stage in the game then to where it's life or death, face death: What the hell, let's do it.

They kept the governor informed as to what was going on—and what he did was beautiful. He had the city patch it in to Peterson's car on the bullhorn, in order to keep himself clear. He said, "Peterson, get your ass out of there, you know you don't have

any business out there doing that!" So he had just covered his butt. A state trooper looked back at Peterson, look at each other and shook their heads, and they packed their stuff in the car and pulled off. The bottom line was that it wasn't legal, but "by any means necessary" was their program, and it didn't work. —DB

You think back on these things and wonder, "How can people be like that?" —AW

What it did was really throw salt on wounds that had been festering for so long; when it opened up, then it was time to bleed, in a sense. Then at the same time, there was an antidote for healing it. That scar will be there but it's

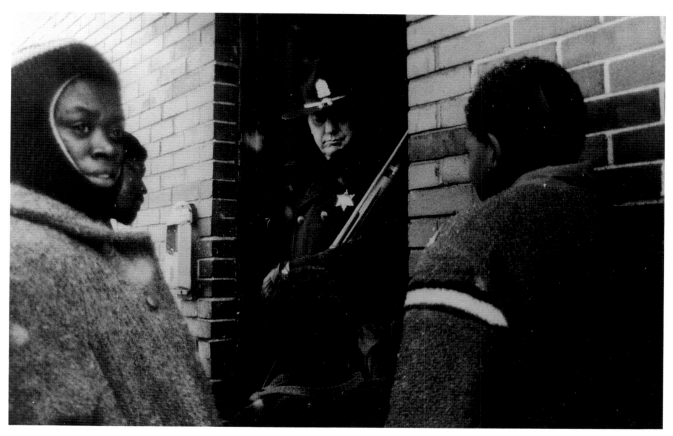

State police officer blocks residents' entrance to their apartments during the firearm search. Pyramid Court. January 1971.

healed. So in other words, it reminds me never to leave it open, for society never to get that close to me that way again. It showed me how really ruthless and treacherous a system can be; not in small, minute areas but universally. —DB

[We still need] work, you understand, to make a living for [our] kids. Cairo's always been structured where you see Oshe, you see the young Oshe; you saw Judge Spoeman, you see the young Judge Spoeman; you saw Smith, the head of the union, now you see his son in the same position. Before it was their parents sending us to jail; now it's the younger generation sending us to jail. —CD

I would say this about today: it's the same old thing, only camouflaged. Back then, they just came on out with it; they didn't care what they said. But today, it's the same old chicken, just warmed over. —HM

You know we have come a long way, but still we don't have it. When the white man has control, he has control. There's nothing we can do. He can pay the cost, or you got to do what he say, or you got to move on. Just as simple as that. We are trying to get together to build the town back up. To see what it takes or what we can do to bring people together. To let them realize this is our home and that we need places of business and that we need to build it up,

whether it's black or white owners. That we need to start doing it together, because that's the only way it's going to happen. —FS

Those were great times—those were different times, those were times of dedication, and people were more sincere than what they are today. And they will not have to go through the times that we went through back then; they don't have to go, because of some of the people, sacrifices they made back then. It's better for them now and it is; it's a lot better here in Cairo, and the country, than it was twenty, twenty-five years ago. Not that everything is perfect, but it's better. —CM

What I say is that the Civil Rights Movement helped the white people here too. Can you imagine, being required to everyday—in any decision that you make that has to do with black people—that being white, it's written as to how you're to interact with those people? Now, to me that's got to be a burden. I've always said that white people here carried a burden also. Victims also have a burden: the burden of injustices heaped on them. But the Civil Rights Movement lifted a burden from white people, too. It set them free, in part. They can be completely free if they want to.
—Preston Ewing Jr.

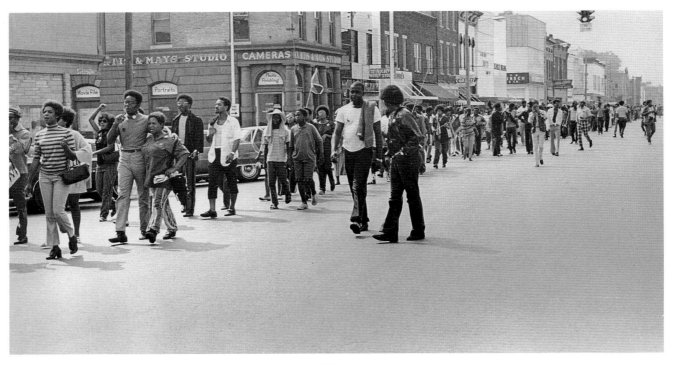

One of the largest protest marches in Cairo. Commercial Street. July 1970.

IN BLACK AND WHITE

Constructing History and Meaning
in Civil Rights Photography

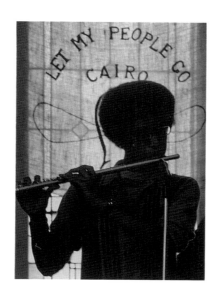

IN BLACK AND WHITE

Constructing History and Meaning
in Civil Rights Photography

Cherise Smith

Since its invention, photography has been regarded as a medium with the ability to record reality objectively. The belief that the camera inherently documents the truth and shows reality is based on the mechanical nature of the process. Photo-scholar Allan Sekula asserts that "photography, according to this belief, reproduces the visible world: the camera is an engine of fact, the generator of a duplicate world of fetishized appearances, independent of human practice."[1] In its early history, photography was not considered an artistic practice. Rather, it was thought that the photographer had little choice in the representation or form that resulted. The fact that photography instantly freezes moments reinforces the perception of objectivity. The photograph brackets an event or individual and removes it from its original context. Once extracted from the initial time and place, the photographic image can be scrutinized and pondered from a safe distance. As an authoritative representation, the photographic image in black and white is the quintessential document: the authority of newspaper and magazine text printed in black and white legitimates and authorizes the photograph. Deriving veracity from the print media, photographs seem to declare, "here it is *in black and white.*"

Photography is, however, anything but an objective record of reality. Henry Luce, media magnate and owner of *Life* magazine, noted the photograph "can also be a commentator. It can comment as it reports. It can interpret as it presents."[2] Photographs are human endeavors, the result of a decision-making process that is undeniably framed by social ideology. The perceived veracity of photography, in combination with the aims of particular individuals and institutions, has facilitated the use of photography toward specific social ends. Photographs have been used as documentation and evidence in instances that range from judicial cases to rallying support for social movements.

The body of documentary photographs taken during the civil rights era is an impressive example of images affecting social change. The role of photography transcended standard documentary usage, surpassing basic historic verification and application as evidence. Against the backdrop of the Civil Rights Movement, the uses of documentary images will be examined by establishing how social documentary photographs were employed in earlier movements. The valuation of civil rights imagery as history—especially how institutions have benefited from that valuation—will be considered, as well

as the ways in which civil rights images function in contemporary American society.

The *International Center for Photography Encyclopedia* defines the nature of documentary photography as telling "a story factually, visually and compellingly."[3] According to that definition, documentary photographers seek to communicate the essence of events, hoping to influence social change and provoke critical discourse in politics and the social sciences.

The intention to use images in a documentary capacity mandates adherence to certain conventions established by the institution, the dominant power structure that holds authority.[4] Constituents of the institution may include government, the media, the education system, corporations, and so on, and each constituent influences the others. The various elements function as vehicles through which the dominant ideology is disseminated. The notion of truth is assigned to documentary representation by the institution. The institution has a stake in the veracity of documentary representation, because it is through documentary imagery that ideology is enforced. Hence, documentary representation is imbued with objectivity, rendering artistic representation subjective and suspect.

As John Tagg explains, the goal of documentary imagery is not merely realism, nor is it just the ability to make a figurative representation from the reality.[5] A successful documentary image is a fusion of the two: capturing the commonness (individuality) of reality, while depicting it symbolically. These images are presented under the auspices of objectivity in an attempt to communicate a story in a persuasive manner. However, the documentary photographer often has a specific social and political agenda. The myth that the documentary photographer's primary goal is capturing the reality of an event, sacrificing all formal considerations, has been carefully cultivated. Removed from the photographer's intentions, documentary images are then framed by certain institutional elements, including government, the media, and the academic system.

The convention of documentary photography was established in the nineteenth century. As early as 1890, Jacob Riis photographed New York's laborers, immigrants, and children, calling attention to their low standard of living, as well as to their growing numbers. In his book *How the Other Half Lives*—a title that bespeaks his identification with the dominant class—photographs supplemented the largely sociological text on the life of inhabitants of tenements of New York. Early in this century, Lewis Hine photographed people from the working class to encourage labor reform. Hine viewed documentation with the camera as a way of empirically proving certain social conditions, as is evidenced in his statement, "If I could tell the story in words, I would not need to lug a camera around."[6] Hine's images were printed in grass-roots publications to disseminate evidence of the necessity for improved labor laws.

During the Depression, the Farm Security Administration (FSA) commissioned photographs to document the circumstances of American citizens.

Under the supervision of Roy Stryker, the government subsidized photographers who could supply imagery to illustrate newspapers and magazines, to demonstrate government statistics, and to promote patriotism. Dorothea Lange, Russell Lee, and Walker Evans, among others, documented the rural and urban poor, the unemployed, and migrant workers. Stryker asked the photographers to provide "pictures of men and women, and children who appear as if they really believed in the U.S. Get people with a little spirit. Too many in our file now paint the U.S. as an old person's home . . . [where] everyone is too old to work and too malnourished to care much what happens."[7] The impetus for the creation of the collection of FSA photographs was ostensibly documentary. However, used propagandistically, the photographs also served to create a uniquely American identity.

THE CIVIL RIGHTS MOVEMENT

Since Africans were first brought as slaves to America, there have been efforts on the part of black Americans to attain freedom and equality. Harriet Tubman and the Underground Railroad, Frederick Douglass, and W. E. B. Du Bois have all participated in a long tradition of struggle toward civil equality in this nation. The long-term goals of the most recent Civil Rights Movement (starting with *Brown v. Board of Education* in 1954 through the early 1970s) were the termination of legal and de facto segregation and the attainment of the freedom to vote. As was the case in earlier struggles, the seemingly small acts of passive defiance by common people created and perpetuated the momentum of the movement.[8]

The movement was sparked in 1955 when Rosa Parks refused to give up her bus seat to a white man. The Parks' incident spawned the Montgomery Bus Boycott (1955–56) that was organized by the local Women's Political Council and the NAACP (National Association for the Advancement of Colored People). The ban effectively shut down the city's public transport system and presented an opportunity for the U.S. Supreme Court to rule against segregation on all such public systems.

In 1957, the seemingly simple attempt of nine teenagers to integrate the Little Rock High School became the stimulus for a further ruling against segregated education. The Freedom Rides of the summer of 1961, arranged by CORE (Congress of Racial Equality), were organized to test the level of integration of Southern bus stations. The Freedom Riders, mostly black and white Northerners, were subjected to violence and arrest. The Freedom Riders' peaceful actions, in conjunction with the violence against them, prompted U.S. Attorney General Robert Kennedy to issue regulations against segregated terminals.

The racist tactics of the state and local government and the notoriety of police brutality against blacks motivated hundreds of civil rights supporters to converge on Birmingham in 1963. Led by Martin Luther King Jr., the supporters, some just children, confronted hostile police officers and firemen

and were arrested. The nonviolent demonstrations of the civil rights supporters countered by the vicious acts of the segregationists prodded the Kennedy administration to hammer out a settlement with the Birmingham government to end segregation of public facilities and to increase employment of blacks.

Later in the year, 250,000 people marched on Washington to show their support for President John F. Kennedy's proposed civil rights legislation and the movement in general. The assassination of President Kennedy and the bombing in Birmingham preceded the passage of the Civil Rights Amendment in 1964, and the voting rights of blacks still had not been secured. The Freedom Summer (1964) and the Selma March (1965) organized demonstrators against restrictions on the voting rights of black Americans. The violence against supporters and workers during demonstrations focused international attention on the struggle, until the Voting Rights Act of 1965 finally secured the right to vote for the nation's African American population.

After the passage of the Voting Rights Act, the Civil Rights Movement changed direction. The thrust of the movement initially had been geared toward action in the South. From 1965 onward, the energy was focused on the North and on cities where African Americans had voting rights but were politically powerless and disenfranchised. Urban rage and discontent spawned the Black Nationalist movement. Black Nationalists, like Stokely Carmichael and Bobby Seale, and the Nation of Islam encouraged self-reliance and considered militarism a viable measure in the pursuit of equality.

By 1968, Martin Luther King Jr. had broadened his scope to encompass all under-represented individuals. "The black revolution is much more than a struggle for the rights of Negroes," he stated. "It is forcing America to face all its interrelated flaws—racism, poverty, militarism and materialism. It is exposing the veils that are rooted deeply in the whole structure of our society. It reveals systematic rather than superficial flaws and suggests that radical reconstruction of society itself is the real issue to be faced."[9] On April 4 of the same year, King was assassinated in Memphis. His death instigated actions that continued the momentum of the movement, but by the 1970s, division among the factions of civil rights organizations were impeding the earlier strides made by the movement.

PHOTOGRAPHY AND THE MOVEMENT

At many demonstrations, photographers were present as representatives of grass-roots organizations such as the SNCC (Student Nonviolent Coordinating Committee) and the NAACP and as staff photographers for national publications. Not only were they assigned to be there to record events, oftentimes they were committed participants in the rallies. Two such photographers are Moneta Sleet Jr. and Preston Ewing Jr.

As a staff photographer for *Ebony*, a predominantly black feature maga-
zine, Moneta Sleet Jr. recorded the Civil Rights Movement from the peace-
ful demonstrations to rebellion-ravaged cities. Sleet's first civil rights
assignment was in Montgomery where he covered the bus boycott in 1956.
His images illustrated articles that updated black Americans on the progress
of the boycott and introduced the leader of the demonstration, Dr. Martin
Luther King Jr. Representing the black press, Sleet was part of the entourage
that accompanied Martin Luther King Jr. to receive the Nobel Peace Prize in
1964. Sleet produced a large body of work during the Selma March. His

Coretta Scott King
and daughter Bernice
at the memorial
service for Dr. Martin
Luther King Jr. Atlanta.
April 9, 1968.

Photo by Moneta Sleet Jr.,
reprinted by permission of
AP/Wide World Photos.

photographs record and testify to the indomitable courage of the marchers. One of his last civil rights assignments was the funeral of Dr. King. As the only member of the black press inside the church during the service, Sleet produced the Pulitzer Prize-winning image of Bernice and Coretta Scott King at the memorial service. Sleet framed Bernice and her mother with a tight focus, leaving the other funeral attendants slightly blurred. That framing, combined with the pointing, right-angled pew arm, makes Coretta Scott King the focal point. By photographing the widow and child close to the picture plane, the photographer focuses the viewer's attention, demanding empathy with the King family grief. "My basic feeling about the movement, of course, I was observing and trying to record, but [I] also felt a part of it because I'm black," Sleet remarked. "The area and the type of work I do has been one of advocacy, I think, particularly during the Civil Rights Movement, because I was a participant just like everybody else. I just happened to be there with my camera. I think that I felt and firmly believe that my mission was to photograph and to show the side that was the right side."[10]

From 1967–73, Preston Ewing Jr. recorded the Civil Rights Movement in Cairo, Illinois, a stronghold of segregation in the North. Ewing first used his photography to illustrate his publications advocating the rights of children while he was working as an education consultant for the national office of the NAACP. Ewing later realized that photography could be used in the cause for civil equality. Along with two other photographers, Ewing recorded the local movement.[11] His documentary images of the town's struggles and demonstrations were used as evidence in court cases and as illustrations in regional and grass-roots publications, such as the *East St. Louis Monitor*, a weekly black newspaper. In his photograph of a young woman holding a sign reading "Dignity," Ewing produced a compelling image that testifies to the spirit of the Civil Rights Movement and to the commitment of its workers (see page 50). By photographing the woman close up, he focuses all attention on her expression. The angled sign frames the woman, while declaring the dignity she and many other individuals felt about themselves and the movement. Beyond their evidentiary capacity, images such as this one testified to the struggle of the workers and inspired the town's civil rights supporters. Ewing considered his photographing of the local movement a way to tell the story visually, but he felt his greater contribution to the cause was his organizational work: "We had such a coordinated effort. I never saw myself as a photographer. I was doing so many other things. People saw me as a chairman of the board of the Land of Lincoln Legal Assistance Foundation, as president of the local chapter of the NAACP, as an organizer of marches. . . ."[12]

The role of photography in the Civil Rights Movement was based on its documentary quality. Photographers were assigned to cover demonstrations and record the history and spirit of the movement. The media, which took

on a responsibility to address segregation, regularly printed stories that focused on the issue of civil equality. The frequent publication and wide dissemination of photographic images via news and grass-roots agencies increased the visibility of the movement.

Civil rights imagery functioned to create different representations of African Americans. Until the 1960s, the representation of African Americans in the media was hardly complimentary. Television shows such as *Amos and Andy* and *Beulah* presented black Americans either as lazy and dim-witted or as complacent individuals who were happy to spend their lives in the service of whites. Alternately, during the late 1950s and early 1960s, television news programs had been presenting updates on civil rights demonstrations. The violent acts of segregationists against the peaceful demonstrations and their supporters were brought into the living rooms of millions of Americans. Viewers were bombarded with still and moving images that gave witness to the courage of black and white Americans in the struggle for civil equality. The imagery in the print media and on television facilitated white America's view of black Americans as deserving of, and extremely committed to, their own civil rights, eliciting strong responses from the federal government as well as common people.

The constant coverage of demonstrations and wide distribution of images in national and grass-roots publications and on television encouraged support from individuals of all backgrounds by representing African Americans as courageous, while at turns representing them as victims. The images also perpetuated the notion that blacks were incapable of affecting change on their own and thus needed assistance from outside sources. The representations of African Americans in civil rights images may be more positive than earlier representations; however, the imagery maintained a destructive status quo.

CIVIL RIGHTS IMAGERY TODAY

In some photographs, a process occurs in which the image becomes an icon. An icon symbolizes the image it represents, calling up certain notions assigned by the dominant institution. Icons contain a myriad of meanings; they have different connotations for different groups of people. In other photographs, a process occurs in which an image acts even beyond its representational and iconic function.

Ansel Adams's *Clearing Winter Storm*, a dynamic depiction of Yosemite National Park taken in 1944, is an example of this process. Adams was a master at capturing and heroicizing the American landscape. By imbuing the landscape with magnitude, he created a notion of America as a grand country. Considering himself a specialist in darkroom technique, Adams strove to dramatize his prints by heightening tonal contrasts, as is the case in this photograph. Sloping mountains on the left and right of the image frame a misty

dome and peak in the distance, establishing the immense scale of the environment and creating the illusion of great depth. Trees in the foreground form receding lines that, combined with the variation of light, draw the viewer deep into the picture plane and intensify the sense of depth. *Clearing Winter Storm* captures not only the mountains and the storm but the environment for miles around, at a rare and magnificent moment that most visitors will never see. The magnitude of the physical scale is reduced to the scale of the printed artifact as defined by the photographic page. This distillation enables the viewer to consume, and thus believe that she/he has experienced, the magnificence of the environment. As an icon, Adams's *Clearing Winter Storm* embodies the concepts of Nature and the American West, yet it functions beyond its symbolic and iconic value. It becomes a substitute for firsthand knowledge of the actual environment.[13]

Through a similar process, the body of civil rights photographs that recorded the historic events have become part of the history of the movement itself. They exceed their mnemonic function of simply recalling the memory of the events. The images transcend their original symbolic significance as mere representations of the movement; they are substitutes for experiential knowledge of the struggle. Surpassing their iconic value, the photographs are physical evidence and actually embody the Civil Rights Movement.

Illinois state police officer with camera. Cairo. Date unknown.

There is power in recording the past and creating history. The individual recording the event controls what will be remembered, and through the process of contextualization, the institution determines how. Many images of the Civil Rights Movement focus on violence. As cultural critic Walter Benjamin states, "To articulate the past historically . . . means to seize hold of a memory as it flashes up at a moment of danger. . . . The danger affects both the content of the tradition and its receivers."[14] By representing the violence of the movement, the institution cultivates sympathy for the participants while it generates quiet resistance to struggle. In this way, the institution uses the historical documents of the movement to breed complacency in Americans. At this point, the movement is infinitely more accessible as photographs—as objects that can be brought out and put away when desired. Martha Rosler has asserted, "Documentary testifies, finally, to the bravery or (dare

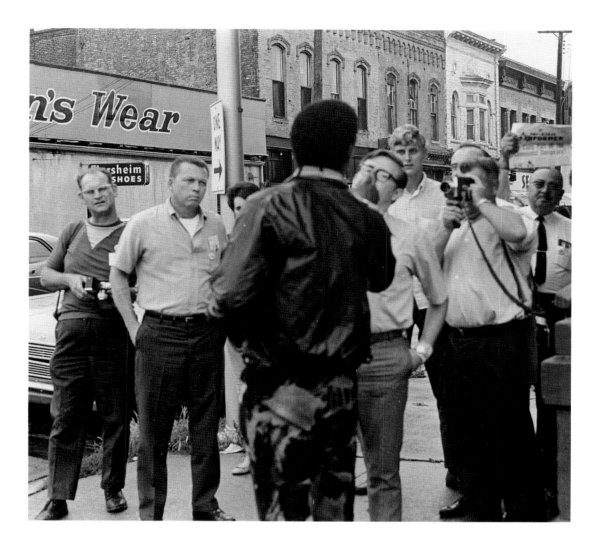

we name it?) the manipulativeness and savvy of the photographer, who entered a situation of physical danger, social restrictedness, human decay, or combinations of these and saved us the trouble."[15] Captured images of the movement render it manageable. The violent struggles for civil rights are safe in photographs; hand-held, they can be put away when wanted.

Walter Benjamin suggests that history is inextricably linked to redemption; that through history, individuals seek restitution.[16] Contemporary use of civil rights images serves to redeem a certain population, while appeasing another. To address these issues, the ends to which the imagery are being used as well as those groups who control the usage must be examined.

Civil rights imagery is present in all aspects of contemporary popular culture. On television, the program *I'll Fly Away* depicts the separate but connected lives of a white man and a black woman in the South during the 1960s. Feature films such as *Malcolm X, Mississippi Burning*, and *The Long Walk Home* portray fictionalized accounts of historical events or individuals of the Civil Rights Movement. Important leaders of the movement appear

Local white citizen with movie camera. Downtown Cairo. Date unknown.

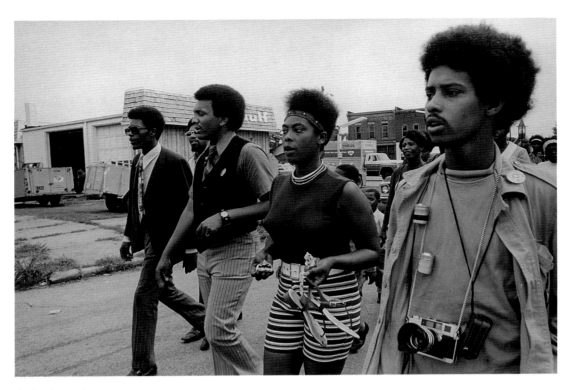

Civil rights worker
Carl Hampton with
camera. Cairo. Date
unknown.

on T-shirts and hats worn by individuals of varying circumstances. Museum exhibitions and books observe the movement by examining the deeds of civil rights leaders and by celebrating the individual photographers who recorded events.

Civil rights images have been appropriated by the institution in many formats for several reasons. The appropriated imagery purportedly proves that the struggle existed and testifies that legal segregation was terminated and voting rights were secured. The assumed images encourage Americans to trust democracy, functioning as proof that civil inequality no longer exists in this country. The imagery is manipulated to promote a sense of complacency, as if all is right in American society.

The institution commands the use of the images, attempting to keep the peace by communicating to white America and to under-represented America. The appropriated civil rights imagery communicates to white America that the movement took place in the specific temporal period of the 1960s and no longer exists; it also communicates that the battle for civil rights was fought and won, purporting that all Americans have equal chances. The assumed images attempt to communicate to the under-represented population that segregation is a thing of the past, that the spirit of sacrifice (nonviolent or violent) had a place during that period but is unnecessary now. Civil rights imagery is being appropriated to revise history. Some recent characterizations emphasize the self-realization of black Americans, which dually commends black Americans and reasserts this notion to white Americans. Other characterizations depict the role of white Americans as crucial in the

movement; this action both praises that population and reminds black Americans of the influence of white Americans. In the end, the dominant institution appropriates the imagery to revise history as well as to stroke white America, while ameliorating the persistent suspicions of under-represented Americans that equality is not a given.

For members of the under-represented population, civil rights imagery functions as a means to communicate one's identification with the movement. Displaying images of civil rights leaders in photographic reproductions or on clothes calls up the pride and self-sacrifice that characterized the movement. Images of Malcolm X, for example, communicate that the owner is aware of, and perhaps in accord with, Malcolm X's early belief that blacks must obtain their freedom "by any means necessary." Civil rights imagery may also be used to evoke a time when blacks were more unified, working together for common goals. Civil rights images serve different roles for different populations.

Ultimately, the body of civil rights images documents an important era in world history. However, "there is no document of civilization that is not at the same time a document of barbarism."[17] Civil rights images were produced by individuals whose decision-making processes were shaped by the ideology of the contemporaneous society. In addition to being influenced by social ideology, the photographer created the image directed by his or her own beliefs. Once removed from the photographer's control, images are then subjected to an editorial context that can augment, detract from, or completely change the meaning the photographer intended.

Photographs are imbued with messages defined by the institution and used toward specific ends. As conveyers of ideology, images contain considerable power in shaping our thoughts and beliefs. Meaning can be assigned to imagery as an instrument of social control. Thus it is imperative to look critically at the definitions and contextualizations of civil rights images. However, the significance of civil rights imagery must not be overlooked. Removed from their various contexts, images of the movement are still historically relevant. They document a revolutionary period in American and world history when a people peacefully demanded their civil equality. Civil rights images must be regarded as the historical documents they are. In this light, their importance cannot be overestimated or denied. In addition to their historical significance, these images testify to the commitment, courage, and perseverance of the participants, while bearing witness to the tenacity of the photographers.

Notes

1. Allan Sekula, "Dismantling Modernism, Reinventing Documentary (Notes on the Politics of Representation)," in *Photography Against the Grain* (Halifax: Press of the Nova Scotia College of Art and Design, 1984), 56.

2. Quoted in Glenn Willumson, *W. Eugene Smith and the Photographic Essay* (New York: Cambridge University Press, 1992), 16.

3. *International Center for Photography Encyclopedia of Photography* (New York: Crown, 1984).

4. For a discussion of power and authority, see Michel Foucault, *The Order of Things* (New York: Random House, 1970).

5. For a Marxist discussion of the social and ideological formation of 'realism,' see John Tagg, "The Currency of the Photography," in *Thinking Photography*, ed. Victor Burgin (London: Macmillan, 1982), 110–41.

6. Quoted in John Tagg, *The Burden of Representation* (Amherst: University of Massachusetts Press, 1988), 195.

7. Roy Emerson Stryker, *This Proud Land: America 1935–1943 as Seen by the FSA Photographers* (New York: Secker and Warburg, 1973), 188.

8. For a history of the Civil Rights Movement, see Toby Kleban Levine, ed., *Eyes on the Prize: America's Civil Rights Years* (New York: Penguin, 1987).

9. Quoted in James Melvin Washington, ed., *A Testament of Hope* (San Francisco: Harper and Row, 1986), 7.

10. Moneta Sleet Jr., interview with the author, December 1992.

11. James Brown and Carl Hampton also recorded the Civil Rights Movement in Cairo, Illinois. Preston Ewing Jr., interview with the author, November 1994.

12. Ewing, interview.

13. In the cases of Adams's photograph specifically and civil rights images generally, the subject is decontextualized, then mannered to create a specific response from the viewer. As Allan Sekula has stated, "Photographs, always the product of socially specific encounters between human-and-human and human-and-nature, become . . . reified objects torn from their social origins." Sekula, "Dismantling Modernism," 46.

14. Walter Benjamin, "Theses on a Philosophy of History," in *Illuminations* (New York: Schocken Books, 1968), 255.

15. Martha Rosler, "In, Around, and Afterthoughts (on Documentary Photography)," in *The Contest of Meaning: Critical Histories of Photography*, ed. Richard Bolton (Cambridge: MIT Press, 1992), 308.

16. Benjamin, "Theses," 256.

17. Benjamin, "Theses," 256.

CONTRIBUTORS

Narrators

PRESTON EWING JR., whose photographs are featured in this book, was born in Cairo and left after high school to further his education. He came back to Cairo to live, while working and traveling for the national office of the NAACP. He served as the president of the local chapter throughout the most turbulent years of civil rights activities. Ewing became involved in photography after recognizing its value as a tool: first in education publications, then in communication efforts for the local movement. The father of three daughters, he has long worked as a consultant in the area of the educational rights of children. Presently, his primary photographic concern is taking and collecting images that will enhance the historic collections he is compiling. These collections will become part of the Ewing/Kendrick Museum of Black History, slated to open in Cairo in the near future.

DAVID BALDWIN (DB) was born in 1941 in Clarksdale, Mississippi, and came to Cairo with his family ten years later. Like most young people from Cairo, he moved north to urban areas shortly after high school in search of economic opportunity. He established a successful barber shop but then was drafted into the military. After serving in Vietnam, he eventually returned to Cairo. He was the president and founding organizer of the "Cool Gents," the predecessor to the United Front, and helped develop the Arts and Crafts Council, which established a recreation center for young adults as a part of the larger civil rights activities in the community. He is currently involved in several independent business ventures while working as a janitor for the Cairo School District. He is still involved with Cairo youth through the Parent Council and Teen Awareness programs.

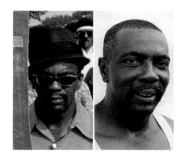

CLARENCE DOSSIE (CD) was born in Cairo in 1943, left after high school, and lived a while in St. Louis and Chicago for employment reasons. After returning home, he became involved in the movement through the United Front. As a coordinating officer in the organization's St. Louis office, he still remained active in Cairo, serving in roles such as parade marshall. He has been a member of the local Laborers Union for over seventeen years. He still speaks out against unfair hiring practices and inequities in economic opportunities for blacks in the area.

HERNEAN MALLORY (HM) was born in Cairo in 1925 and still maintains her home in Future City on the outskirts of the Cairo community. Her involvement in the movement came as a result of her guiding religious faith that commanded her actions then and throughout her life. Along with other local women, Mrs. Mallory gathered and distributed clothing for those in need in Cairo. While working at the Cairo Motel, she reorganized and subsequently directed the United Front Choir. The group traveled around the country raising funds and serving as inspiration for the local struggle. Her daughter Pam and late husband were also active in local civil rights activities.

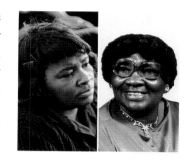

CORDELL McGOY (CM) was born in Cairo in 1952, left after high school for work, but returned shortly to marry. While employed at a local factory to support his wife and three children, he also served his community by his involvement in the struggle for justice. He still works for social and economic growth through his position as mayor pro tem and commissioner for the City of Cairo and as a member of the Cairo Public Utility Commission. He is employed as a Security Supervisor for the Illinois Department of Correction and lives with his wife of twenty-one years.

FLORETTA SIMELTON (FS) was born Floretta Avant in 1949 in Arkansas, where from an early age she worked with family members in the cotton fields, subject to the whims of white property owners. The family moved to Cairo in 1962. She became active in the Civil Rights Movement, participating in picketing, marches, and rallies. She currently directs activities for families and young people in public housing, is the president of the Tenants Council of McBride Court, and is Committeewoman for Cairo's Third Precinct.

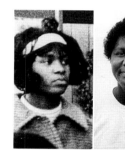

ANNE WINTERS (AW) was born in northern Arkansas in 1918 and moved with her family to Cairo when she was five years old. While her husband worked out of town, she raised six children, sending two of them through college during movement times. While working as a housekeeper, she helped organize delinquency prevention and recreational programs and served on school integration and economic development committees. She had been active in her church throughout her life and continued to serve her community as a board member of the local NAACP and Land of Lincoln Legal Assistance organizations and as a volunteer for Catholic Charities until her death in June 1995.

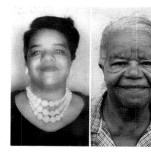

Other Contributors

MARVA NELSON is an essayist, a poet, and a writer currently residing in Carbondale, Illinois. She is the oldest living child out of ten of Claudia and Harold Nelson. Of her life and work, she says, "There is not a day that goes by that I don't hear the voices of my sistermothers urging me to speak their truth."

JAN PETERSON RODDY is an associate professor in the Department of Cinema and Photography at Southern Illinois University at Carbondale. She teaches the history, critical analysis, and production of photography. She continues to work with community photographic archives while pursuing her own photography projects.

CHERISE SMITH holds an MA in art history from the University of Arizona, Tucson, where she specialized in African art and the history of photography. She received a graduate internship at the Metropolitan Museum of Art, was the Romare Bearden Fellow at the St. Louis Art Museum, and is currently a MacArthur Fellow at the Chicago Institute of Art. She has curated several major exhibitions, including "My Point of View: Photographs by Moneta Sleet, Jr.," a nationally traveling show.

COLOPHON

This book was set in Adobe Garamond,
a modern digital version of Claude Garamond's type
cut in 1530. The captions are Gill Sans, designed by
Eric Gill in 1927. The book and jacket design
is the work of Gary Gore. Production was managed by
Rick Stetter and Kyle Lake. The photographs were
reproduced as scanned duotones
by Thompson-Shore, Inc.